AYLESBURY

THROUGH TIME

Charles Close

AMBERLEY PUBLISHING

First published 2011

Amberley Publishing
The Hill, Stroud
Gloucestershire, GL5 4EP

www.amberley-books.com

Copyright © Charles Close, 2011

The right of Charles Close to be identified as the
Author of this work has been asserted in accordance
with the Copyrights, Designs and Patents Act 1988.

ISBN 978 1 4456 0579 1

British Library Cataloguing in Publication Data.
A catalogue record for this book is available from
the British Library.

Typeset in 9.5pt on 12pt Celeste.
Typesetting by Amberley Publishing.
Printed in the UK.

Introduction

It is traditional to begin a local history book about a town with an account of its origins. I am going to stand that concept on its head by starting with the here and now.

Over the last few weeks, the local *Bucks Herald* newspaper has covered such topics as the enormous amount of council taxpayer's money being spent on a theatre project, a giant supermarket in peoples' backyards, and why an increasing number of locals are living rough in vans because they can't afford housing.

At the time of writing, the *Bucks Herald* has a cover story: 'Estate Ghetto Fear.' The article refers to the Buckingham Park development north of town, on the A413. Plans to concentrate social housing into just one area of the estate have enhanced police fears that already high crime rates will get worse on the estate.

Meanwhile, there are plans for around 3,500 new homes west of Aylesbury, at the former Berryfields beauty spot. Building houses is the only way farmers can make serious money, and local authorities are under huge government pressure to accommodate new development. Like it or not, record family breakdown, falling marriage rates and record immigration are increasing the demand for housing, whilst many still cannot afford a home.

Aylesbury has also lost much of its industry, particularly in relation to traditional industry. This is a bustling town, which once boasted coach building, a car industry and state of the art avionics. So what has gone wrong and why do conventional local historians insist on the rose-coloured spectacle approach?

The town has 2,000 unemployed, as well as drug and other huge social problems. This writer was educated in Aylesbury and worked in various jobs in the town. He has witnessed the changes first hand. As a reporter on the notorious *Aylesbury Plus* newspaper, in the 1980s, he was vilified for challenging the town's traditional Tory leanings. It was

the time when big employers like New Holland were leaving town to exploit cheap labour in South America, and council housing was being sold at knock down rates. It was a time when people saw it all with no sense of doubt or foreboding.

Aylesbury Vale is stuck in the 1980s, in spite of record house building. The infrastructure is collapsing, the local hospital is overloaded and roads are close to gridlock. Still the expansion rolls on. Schools are seriously inadequate, crime is running out of control and racial tensions are an underlying issue in a county town where schools are seriously failing and kept afloat by spin.

As a former teacher, I recall an ex-pupil coming back to see me, telling me he was going to be murdered due to his links with local drug dealers. He was murdered in 1990. A local writer captured the horror of this once sleepy rural county town in her novel *Animals*. The locals did not like T. Troughton's tale because it was too close to the truth.

So it is very serious that all of this has happened when the Urban Renaissance Institute comes up with a report stating that the Vale is seriously lacking in any potential for economic growth. Manufacturing used to be at the heart of the town.

Britain as a whole is seriously lacking in potential for economic growth. County Council officers and politicians at all levels are mainly concerned with spin and the illusion that Britain is a democracy – it is an outrage that Bucks CC's Chief Executive takes home basic pay of £250,000 per annum in these high tax troubled times.

It is always the same in modern Britain, identify a serious problem and then say why it is all really OK. Aylesbury is in decline, possibly more so than many other places. It is where Luton was in the 1970s. But, as the authors of *Crap Towns* observed, most of Britain is crap – excepting the expensive rural havens where well-paid civil servants, successful politicians, business types, actors and senior council workers live. There are plenty of those in Aylesbury's surrounding Chiltern environs.

The Romans built Akeman Street, now the A41 and the Great Central Railway put the town on the fast track – that route has come back to haunt comfortable locals with the HS 2 route threat.

The Second World War and then London overspill saw Aylesbury grow to over 20,000 in the early 1960s. Plans to revive the old through rail line, as part of a high-speed rail link (HS2) are being vigorously fought by wealthy homeowners in Aylesbury Vale.

Whether they like it or not, the county's leaders should accept the reality that Bucks is not a good economic performer. Hence it has areas of high social deprivation, juxtaposed with pleasant suburbs and affluent pseudo Old England villages.

Local government cannot be blamed for cramming in massive new residential development. They have to comply with government targets as part of New Labour's spatial growth plan. But did the town need a theatre and does it need a massive Waitrose in the backyard of a residential area?

The District Council reckons that backing the scheme to the tune of £18 million will reap them big rewards, especially with low paid service jobs. Meanwhile front line services face cuts. This is where Aylesbury has come to, through time.

As I write, local public sector workers are getting ready to take arms against reforms of their gold-plated pensions. But why should these people be immune from redundancy when those in the wealth-creating private sector are not?

Before Christmas, I was struggling to make extra money working at the old CBS record factory in Raban's Lane. Workers told me that redundancy was in the offing after Christmas and this seems to be happening now – see *Bucks Herald*, 12 March 2011. We are a long way from the sixties boom years and into the economics of the madhouse.

Aylesbury is very much a dormitory town for the prosperous and a haven for feral youth, drug addicts, criminals and one-parent families. Aylesbury College of Further Education was opened in the mid-1960s, when England was said to be swinging. Swinging, these days, has very different connotations.

By the year 2000, the college had established a reputation as a dumping ground for the town's secondary modern school misfits and feral youth. Knife crime was a persistent danger and police visitors were commonplace as the liberal educationalists paved the way for social decline. The old college was demolished to make way for a splendid new building and more vacuous promises of educational Nirvana.

Hundreds of years ago, it was all rather different; though far from perfect it was a long passage of time that brought us here. However, it would be glib to suggest that the past was kind to its inhabitants – though it was undoubtedly less crowded. Britain is now Europe's most densely populated country. Aylesbury's location, just north of a gap in the Chilterns, made it a natural thoroughfare, bringing the plague, because of the rats that fed off the wheat being carried through town.

Chapter One

Divine Right

Henry VIII put Aylesbury on the political map when he married the lord of the manor's daughter, transferring county town status from Buckingham to Aylesbury. As the new county town, Aylesbury grew in status and threw up some interesting political figures. John Hampden's statue, in Aylesbury Market Square, commemorates him as one of the most illustrious locals.

Hapmden was born in 1595, son of William and Elizabeth Hampden, of Hampden House in Great Hampden. Elizabeth was leading Parliamentarian Oliver Cromwell's aunt.

John represented Wendover in four of Charles I's Parliaments, and Buckinghamshire in the Long Parliament. He had several antagonisms with his king's way of ruling. This culminated in vigorous opposition to the Ship Money tax in 1637.

Obdurate King Charles I ruled by Divine Right and gave no leeway to forces of dissent. Hampden inevitably sided with his mother's family, the Cromwells, during the ensuing Civil War. He raised a regiment in Bucks and helped establish Cromwell's four counties confederacy, crucial to the Parliamentarians success.

Opinions differ as to whether John Hampden died through his own pistol exploding, or was shot twice at Chalgrove Field in 1643. Either way, he just made it back to Thame before he died. His image used to decorate the baker's bags of Pages of Aylesbury, as well as being the name of Aylesbury College's agricultural department – Hampden Hall – now an expensive housing estate.

The town has no statue of John Wilkes, the ugly firebrand politician, denounced as a devil by mad King George III – a king perturbed by the crown's loss of power. Newly married to Mary Meade, John Wilkes started married life at Prebendal House. He became MP for Aylesbury through various seat swapping arrangements with his Whig friends. England was far from democratic, and the move cost him £7,000. Looking across time, this writer cannot see great change in the fact that money influences and corrupts any claim to Britain being democratic.

Over the years, there have been other notable MPs. The Oxford-educated philosopher Timothy Raison took over from the grand Tory Sir Spencer Summers. Since those days, the town has had little voice in a Parliament where political differences have been blurred in an age of Elitist consensus, worrying global economics and politics. These massive forces of change began during the Thatcher years and have turned Aylesbury from a sleepy rural market town in the 1970s to the multicultural muddle that it is nowadays.

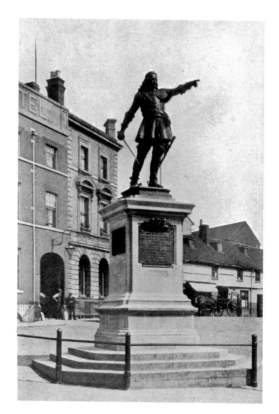

John Hampden's Statue

This was unveiled on 27 June 1912. In 1988, to accommodate redevelopment, the statue was moved 15 yards at a cost of £10,000. Now, instead of pointing a warning finger at County Hall, he points towards a travel agent's.

Today, the base is all boarded up and surrounded by police officers. The English Defence League are, this day, in town and drinking up at the absurdly named 'Aristocrat' pub, on the island created by the Aylesbury's infamous gyro system. They are charging their batteries ready for the march into Market Square. Here they were to demonstrate about what they considered to be England's main problems. Only the police and members of the press, such as myself, were allowed to witness their protest. One wonders whether the EDL presage a new civil war – though mainstream media and spin doctors would proscribe that view.

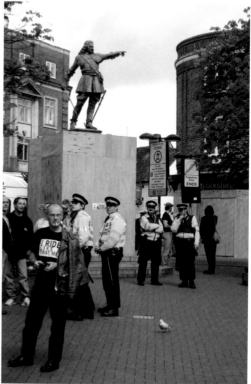

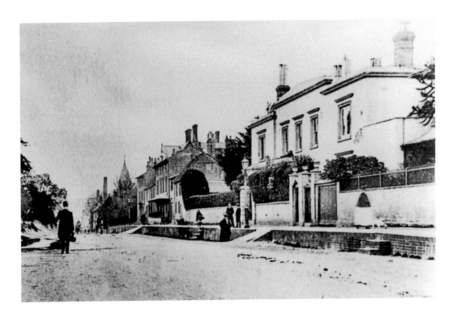

Wendover Road

This view, close to the gyro system, heading north-west into town, was taken *c.* 1890. The roads did not have numbers until after the First World War, when the government was setting about organising funding for maintenance. This road became the A413 and was one of two routes from Aylesbury to London. Bucks County Council was established in 1888, with responsibility for roads and schools. The 2010 image was taken from the same spot. The infamous gyratory system that created an island of a few old buildings, including the Aristocrat pub (formerly the Horse & Jockey), can be seen cutting in from the left. This road is now very busy, as a route to London, local housing estates and the affluent region of the Chilterns.

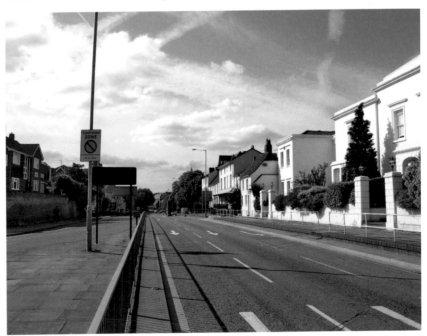

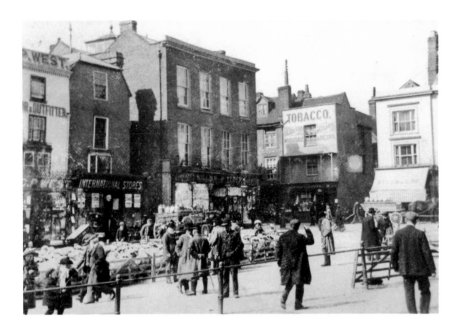

Aylesbury Market Square

Once livestock sales were held there. Market days saw carrier's carts bringing folk in from distant villages. There would be a lot of business, banter and drinking when Aylesbury was still a man's world. The sale of livestock ceased here in 1927. The new market was under the archway, beyond the Corn Exchange. From almost the same spot, May Bank holiday last year, the square looks rather different. It would even seem bland, but for the mysterious presence of police officers. The portable toilets are for an army of police officers from other counties. The area is about to be closed down to all but the police, us card-carrying journalists and the English Defence League (EDL) who were going to march into the square, protesting about what they call the 'Islamification' of Britain. The Council and police ruled that the public should not see the protest. The EDL prepared for the demonstration, meeting in The Aristocrat pub before marching into town.

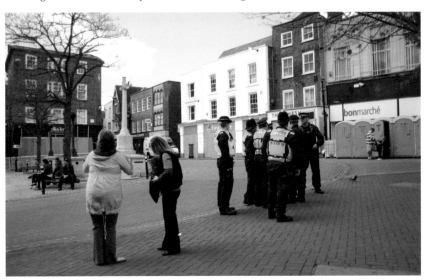

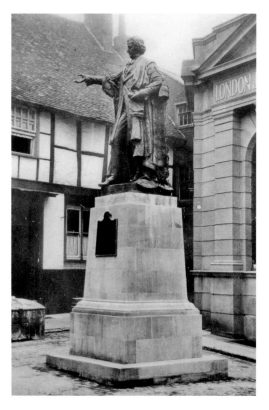

Disraeli's Statue

Benjamin Disraeli (1804–1881) was an unlikely Tory leader. Living close to Aylesbury, at Hughenden Manor, from 1847 until his death, he sometimes visited Aylesbury with his friend Queen Victoria. Decried because he was an imperialist and protectionist, he was also, however, a man of great social conscience, well demonstrated in his novels.

His book *Two Nations* was very much about the exploitation of Britain's hardworking majority by an Elite. It is as relevant today. He was responsible for extending the franchise to skilled working men, paving the way for state education and other reforms necessary to making this country competitive in a world increasingly dominated by a newly united Germany. Disraeli became Earl of Beaconsfield after forty years in Parliament.

This statue commemorates his links with the town. The town has changed a lot, but Disraeli's statue is still at the top of Market Square, where it joins the High Street. The old timber-framed building was the Crown Hotel. Complete with stable yard and bowling green, it was demolished and has been replaced by a dull post-war cubic office block. The London Joint Stock Bank no longer exists, but the little money temple is still there, now owned by HSBC.

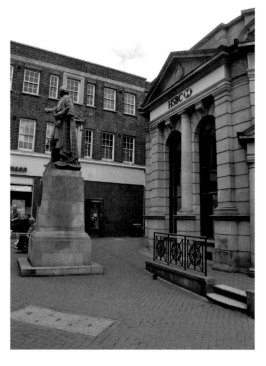

The King's Head Hotel

The hotel at the top of Market Square, is seen here in the 1930s. This fine Tudor inn is now preserved by the National Trust. The name is a reference to King Charles losing his head in 1648 or 1649, depending which calendar you consult. The obdurate Stuart monarch was not prepared to reign under parliament's forward thinking rule, and so he was executed.

Britain's industrial revolution is attributed to the demise of religious absolutism and an open mind about trade. Every era has its dictators, and authority has to be challenged in the interests of justice and progress.

To the many passers-by, the King's Head would appear to have vanished. But it is still there, hidden by modern bland structures. It is a charming place for a lunchtime drink and meal.

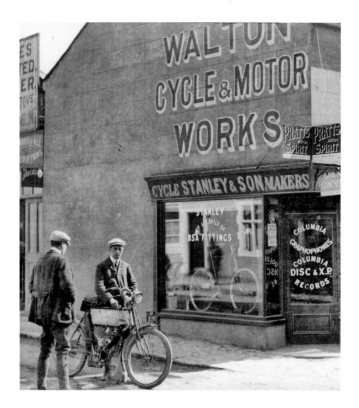

Walton Street

Walton Cycle & Motor Works, Walton Street, 1910. William Stanley began assembling bicycles from Raleigh components when cycling was in its heyday. Increasing his skills, he began to make his own components and ran into patent disputes with Raleigh. During the First World War, his works made shell cases. Most of this site is now taken up by a busy traffic roundabout. The picture of Walton Street roundabout was taken in 2004, while improvements were in progress. The unusual 'Blue Leanie' office building is in the background. The image predates the Waterside theatre development. The *Bucks Herald* still has its offices, left of Wendover Road at the entrance to Exchange Street.

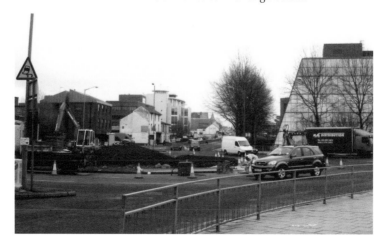

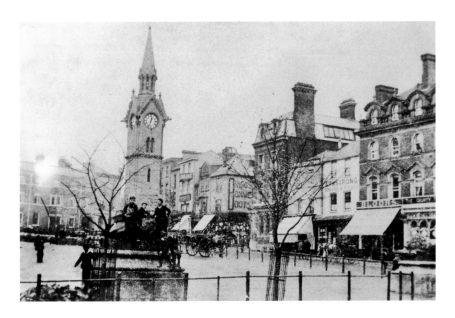

Market Square Pictured from the Crown Court Steps

We see the sort of functional shops necessary to hard-pressed working folk. Britain's biggest Woolworth's was a long way off. This picture was taken at the turn of the nineteenth century. The British Lion statues are there to stir the locals' pride, making sure they were eager to leave the town's shops and farms to fight a foreign foe. The clock tower was built with proceeds from the sale of rubble of Market House, demolished in 1866, and public subscriptions. It cost £882 and opened in July 1876. Standing on the court steps today, we see a gaudy and bland environment. The stretch limo has probably been hired for a stag party. Trees obscure the clock tower and the resurfacing work. Surrounding buildings make this shot easy to place, but change is redolent in the summer of 2010.

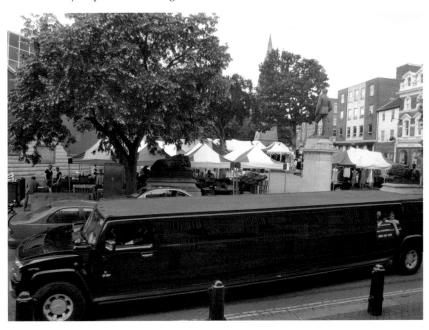

Looking toward the Bell Hotel and the Entrance to Walton Street
This view is now overwhelmed by County Architect Fred Pooley's county offices. The slumbering iron lion, pictured left, was presented by local banker Baron Ferdinand de Rothschild in 1888. Goodridge's dining rooms are on the right, near the entrance to Friar's Square. Gas lighting is also evident. The struggle for street lighting began in 1890, when Colonel Brown opened a subscription for a 'few miserably dull oil lamps' (Gibbs). The town was lit by and could cook by gas in 1834. An electricity scheme began in 1915. From the same vantage point in the summer of 2010, we see the second incarnation of Friars Square.

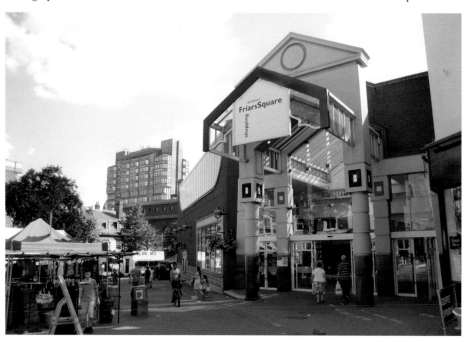

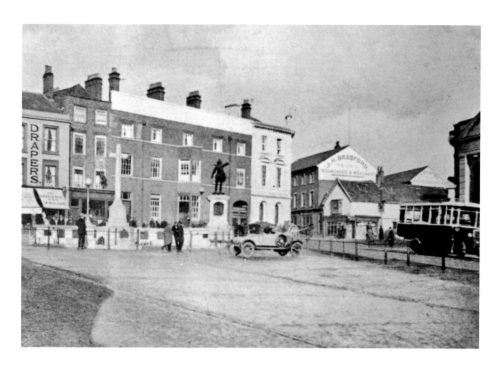

Market Square

In this late 1920s scene, looking toward the entrance to Kingsbury Square, we can see that the motor bus has taken over from the carrier's cart, bringing in the folk for market days and shopping trips. Young's Aylesbury Motor Bus Company pioneered the new way of travel. McIlroy's draper's shop and the George Hotel dominate the building line. The former would be taken over by the men's outfitters Montague Burton in 1936. The war memorial and John Hampden's statue stand proudly in the foreground. The war memorial is still there, but Hampden's statue was moved as mentioned previously.

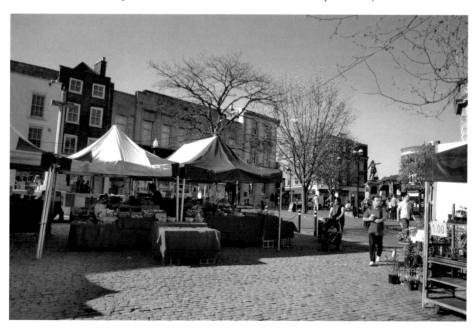

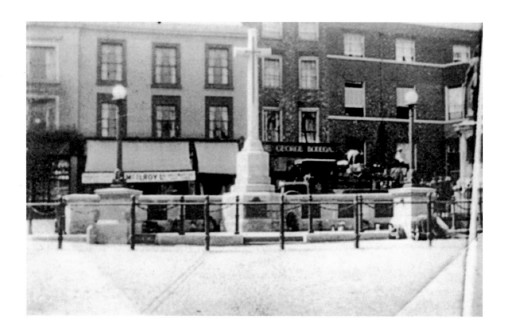

War Memorial

This is a closer view of McIlroy's and The George Hotel, where the draymen's cart is unloading supplies from the local brewery in Wendover Road. McIlroy's did not close until after the Second World War. This early 1920s image shows the memorial to the dead of First World War when it was almost brand new. The war memorial identifies the lower image as the same place as the previous picture. The 'war to end all wars' did not succeed. Many more local dead have been mourned since the so-called 'Great War.'

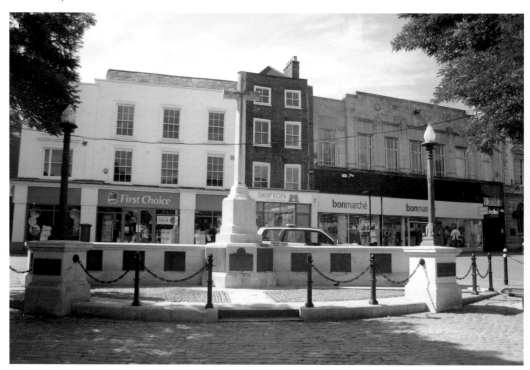

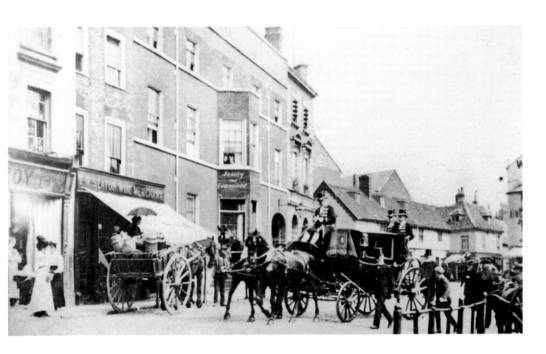

George Hotel, Market Square

Still in the same area, this image shows the mayor's coach and procession passing a block comprising the old army drill hall, the George Hotel and Bodega (Seaton's Wine Merchants), in the 1890s. McIlroy's, the draper's, is just visible on the left. This was formerly Polden & Gurney's, to which ladies used to be delivered by carriage, but the world was changing fast. Close to the same spot last summer, the building line informs us of some similarities. The old Burtons Tailors building occupies the site of the George Hotel. Opened in 1936, Burtons was the best for good quality but cheaper men's clothing. By the 1960s, their slogan was, 'you can't beat Burton tailoring.' McIlroy's is long gone, replaced by a travel agency.

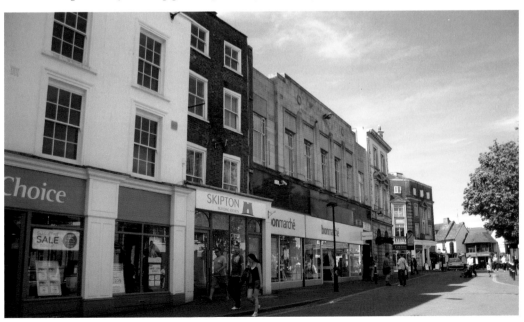

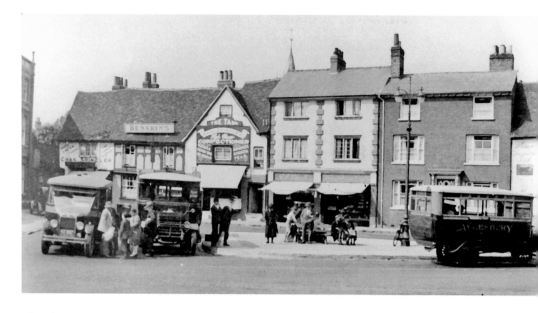

Kingsbury Square

Before the motor bus, people poured in from surrounding villages by carrier's cart on market day. Carriers parked in the yards of the various inns. Buses needed more room to manoeuvre. Kingsbury Square, shown here, was the established terminus for a number of bus operators by 1929. This image was taken during a summer music festival in 2010. The wider camera angle shows Corals betting shop. This building opened as The Record Centre in 1957, by kilt wearing Scottish singer Jackie Dennis. The author dodged through the fans legs to get Jackie's autograph. This was a very busy bus terminus up until Friars Square bus station opened in 1967.

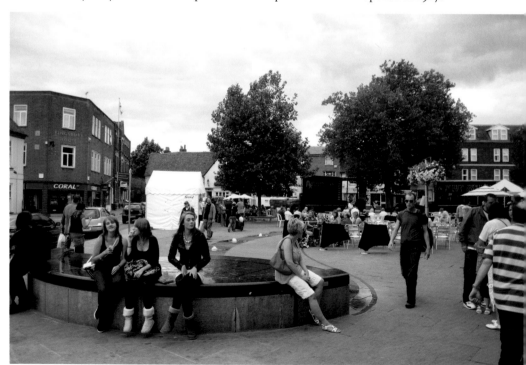

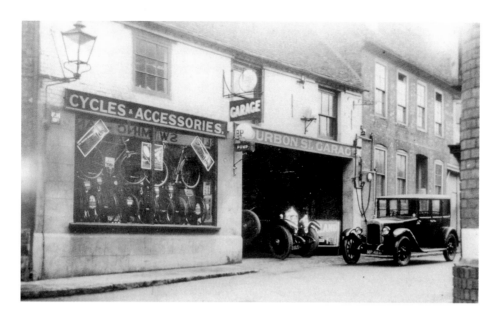

Bourbon Street

Thorpe's Garage viewed from a corner of the old Slipper Baths in Bourbon Street. The word 'swimming' can be seen reflected in the garage shop window, above the bicycles. Motoring was still a novelty for most folk in this 1920s image. Mr Thorpe also ran a taxi service, and Ron Rayner became garage manager soon after the Second World War. Hoggeston-based Armenian millionaire Nubar Gulbenkian had his customised Rolls-Royce serviced here. Murrels discount shop was next door and his tally men, driving Morris Travellers, hawked wares around the local towns and villages until the massive retail upheaval of the 1960s. Murrel offered credit without red tape to people like my family who had so little money. Bourbon Street took its name from the French Royal family. Bourbons fled the French Revolution, some of the family living at nearby Hartwell House, between Aylesbury and Stone. Here we can see the archway leading to the back of what had been the garage.

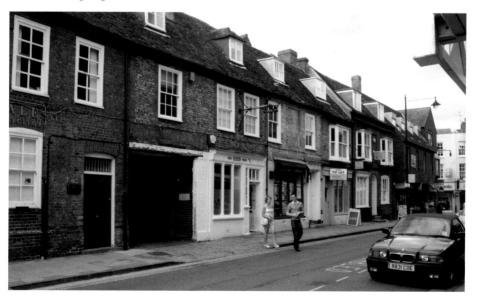

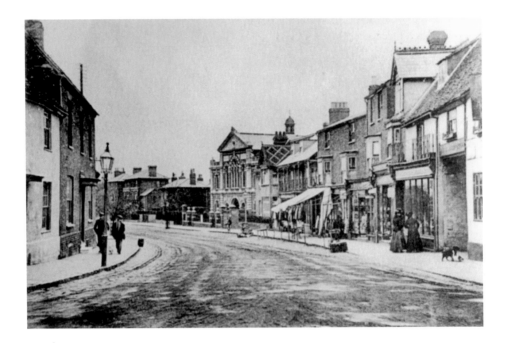

Buckingham Street

The scene looking from the Kingsbury Square exit into Buckingham Street, early twentieth century, evokes a world no living local can recall. These days were very structured by the class system and average wages were low, as were the prices. There were few luxuries, beyond a large number of pubs dominated by working men. This road became part of the turnpike in 1721. Much has changed in this modern scene. The chapel building is still there, but the various Christian denominations have considerably declined.

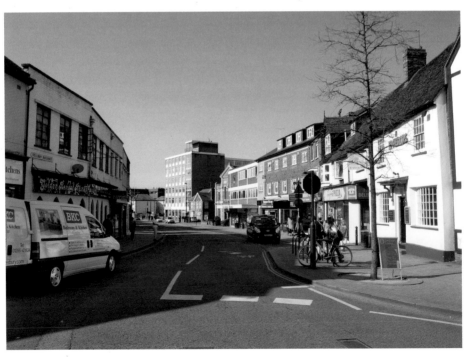

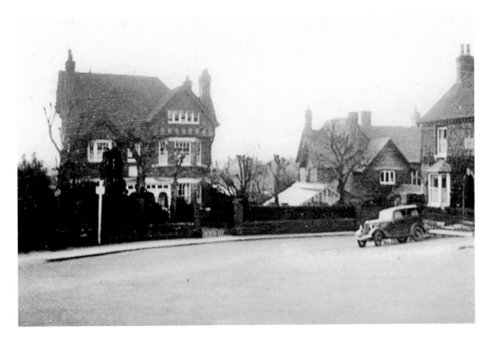

Rickford's Hill

The rambling house on the left makes this image look a bit like Hitchcock's *Psycho* film set. Cars were in short supply for years after the Second World War. The one in the picture is a pre-war Ford. Progress has seen houses demolished and replaced by town centre offices.

Chapter Two

Concrete Age

The redevelopment of Aylesbury's town centre in the 1960s was all about money, just as the latest expansion plans are. Back then, the sleepy county town of well under a 30,000 population was on the cusp of the concrete age.

Town & Country planners, like the famous Professor Buchanan, had been dreaming up idealised car-free town centres in the late 1950s. This was in line with Tory Prime Minister Harold Macmillan's proclamation that the British people had never had it as good as they had under his party's rule. It was the age of hire purchase, or 'never never' payments.

It was also about to become the age of political sleaze, with Macmillan's government falling under the weight of the Christine Keeler and John Profumo scandal. The former was a call girl and the latter her government minister lover. Uniformed RAF Halton camp personnel around town reminded us that the country still had a few withering Imperial responsibilities, but 'times were a changing' according to the sixties protest singer Bob Dylan.

Since 1888, the big old red-brick county offices, police station and court building had dominated a rectangle of land bounded by the bottom of the Market Square, Walton Street and Exchange Street. But they were soon overwhelmed by a vast flow and spread of concrete.

The 1960s were very much about concrete. Pop bands like the Rolling Stones and Unit Four Plus Two came to town. The latter even had a hit called 'Concrete and Clay.' Every big town had a share of concrete as sixties Britain struggled to find self-confidence. The town had been an 'expanded town', taking London overspill since the 1940s. Now its expansion was going into hyper mode.

1968 connected the new shopping centre to Britain's largest Woolworth's shop. F. W. Woolworth was optimistic that a third London airport would be built at Wing, nearby. But opposition and government penny-pinching put a stop to that. Such a large shop then struggled to pay its way. The whole British arm of Woolworth's was struggling. The three -storey Aylesbury shop closed in the 1980s and the whole business failed in 2009.

Aylesbury's shopping centre has struggled with competition from Milton Keynes. It is a worrying situation when success with shopping centres matters more than the town having a diverse jobs base. Engineering enterprises like New Holland and Air Trainers are long gone.

Berryfield

Aylesbury and its environs were still reliant on farming when this tranquil scene was photographed in the late 1950s. The area, west of town, remained unspoiled for over another fifty years (Reg Jellis). Under the Milton Keynes & South Midlands sub Regional Strategy, Aylesbury was required to take more housing. Berryfields was earmarked for a new Aylesbury suburb of 3,500 new homes, shops and a school. This image shows work in progress. A new rail station opened on the opposite side of the A41 called Aylesbury Parkway, which will carry commuters into London. There are also contentious plans to make the former Great Central rail line part of a new high speed rail link – HS2.

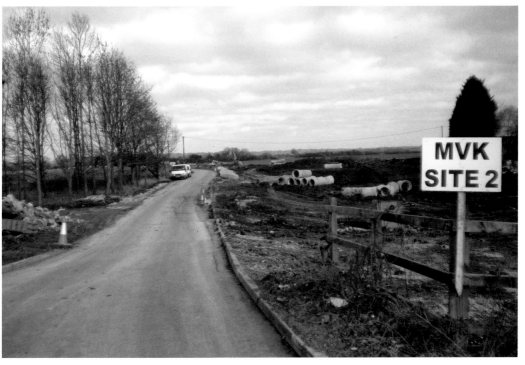

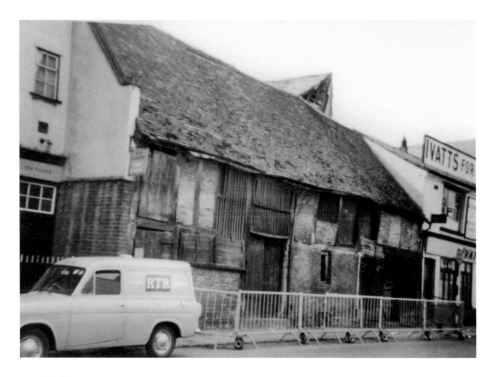

Buckingham Street

A Radio Television Rental Van (RTR) passes Ware's slaughterhouse. Televisions were still expensive enough for rental to provide a cheaper option which was easier to upgrade. The Eagle Pub is on the left. Ivatt's shoe shop, a family business, opened in 1723 and closed in 1983. Very little of the old building line remains today. The shops are all about sport and getting away on holiday with Motts Travel (John Robinson).

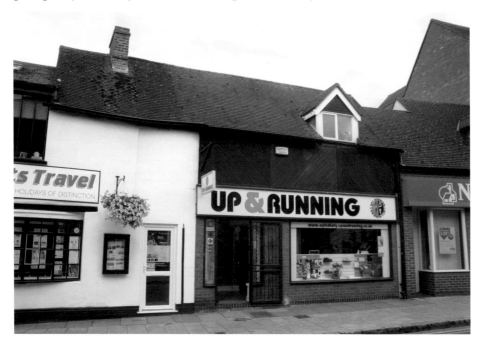

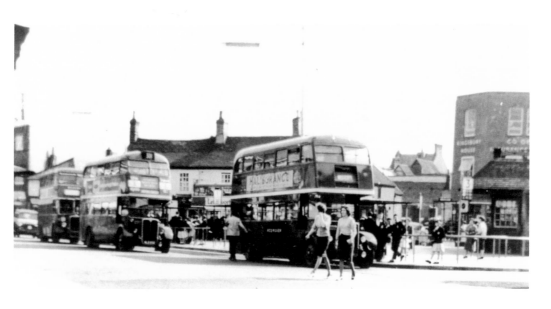

Kingsbury Square

Kingsbury Square, viewed from the westbound exit of its one-way system. Two AEC RT buses close to the camera remind us that this is still the bus station. The nearest bus is a non-standard Craven bodied version of the famous London bus type and was then on Red Rover service to Westcott. The RT behind was on the London Transport country service out to Amersham. The length of the two local beauties' skirts tell us that the 'swinging sixties' have not quite arrived (Colin Seabright). The modern photograph was taken in the summer of 2011. The buses have gone and much of the square has been paved to create a café and more relaxed consumer environment. The drab old County office block, once seen as futuristic, looms above the roofline. The occasion is a rock festival, with the stage provided on the back of a Robinson's removal truck.

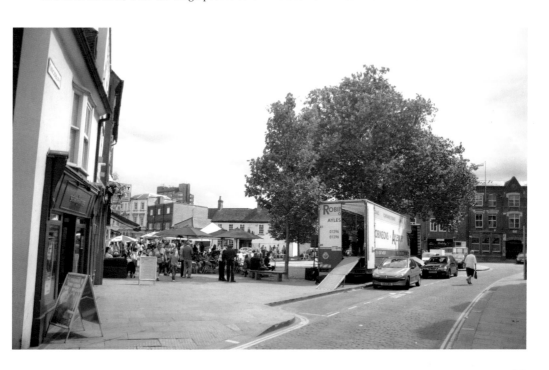

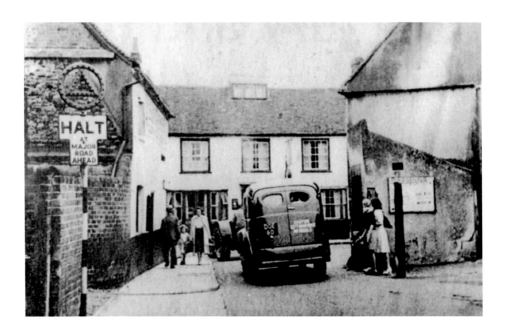

New Street/Cambridge Street Junction

Aylesbury's much needed inner relief road between Exchange Street and New Street was approved in June 1983. This picture shows the junction of New Street and Cambridge Street in July 1947. The poster on the wall behind the two girls is advertising the Granada Cinema; the film showing was *Dual Alibi* with Herbert Lom. The Granada had also been a venue for rock bands, but closed to become a bingo hall in October 1972. Nowadays, development has opened up views of Upper Hundreds and the Royal Mail sorting office on the left, and a glimpse of the High Street shopping area peeping over the bushes.

The Rising Sun

Here is the pub in 1964, shortly before demolition. Back in the seventeenth century it was a welcome sight for weary travellers coming off the Oxford Road and into town via the steep and narrow hill of Castle Street. The advancing ring road ensured its demise (A. J. Read). On a sunny day last summer, the winding hill is still there, but the pub has gone and the area behind has been landscaped, with the trees having grown well.

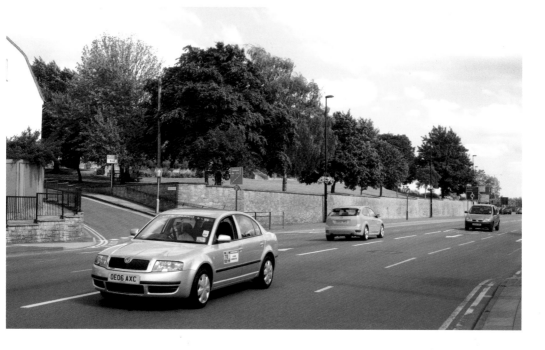

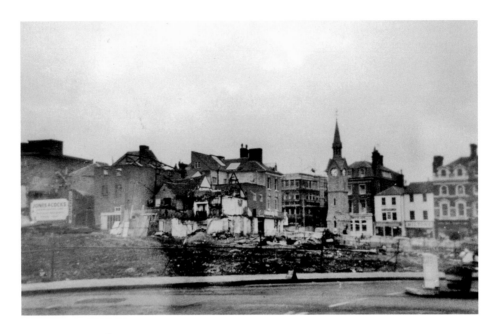

Silver Street, 1964

This mid-sixties view from Walton Street makes the Market Square look like one from the blitz. Old businesses are turned to dust in the area of Silver Street, Silver Lane and Friarage Passage. The once proud name of Jones & Cocks stands boldly painted on a wall that will soon become a pile of rubble. The diggers will come; level the gradient and the concrete and steel shopping paradise of the modern will be poured out into the shuttering moulds (John Reed). By the time this May 2010 picture was taken, the original concrete Friars Square had been stripped to its mainframe and been reincarnated. The stereotypically theatre-like entrance to this new emporium contrasts extremely with the old clock tower that has ticked away the passing years.

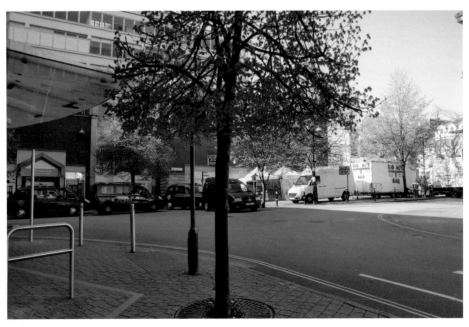

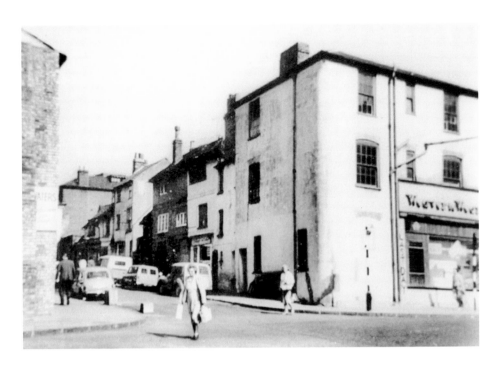

Silver Street/Market Square Junction
The junction of Silver Street and Market Square. The 'last day of sale' sign attached to the wool shop on the right warns that these are the last days in the life of the old town centre (D. J. Huntley). Who would believe that this image is taken from the same location as the previous one? The Friars Square development obliterated Silver Street. The looming concrete office building is redolent of the 1960s, when it was built.

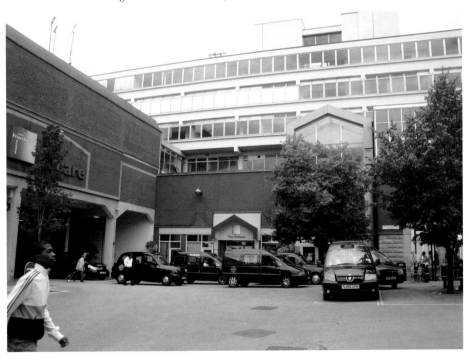

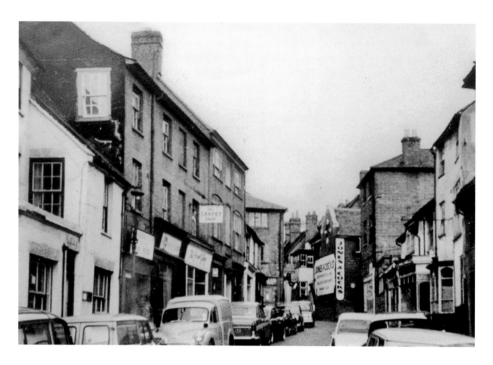

Silver Street, 1964

Just before the demolition crews moved in. This shot shows the charming little Silver Street and a fine display of the best of 1960s motor cars – when Britain still had its characteristic car industry. The rather sinister-looking old Dark Lantern pub is just visible at the top of the hill. The rambling old Silver Street crumbled easily, and its foundations would be levelled and covered in concrete for the new Friars Square development (D. J. Huntley).

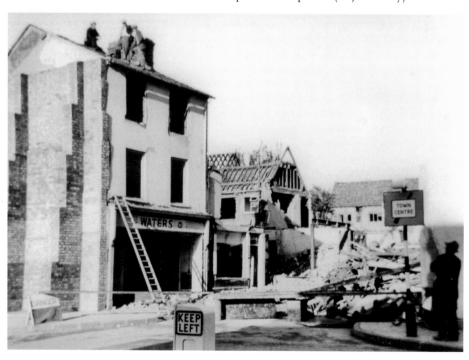

Mango's, Silver Street
A fire at the Dark Lantern pub in 1989 led to rebuilding and a loss of the old smugglers' haunt look about the place. Along with rebuilding came the new name 'Mango'. This picture was taken in August 2010. Another view of the destruction of Silver Street. The lost buildings dated mainly from the sixteenth and seventeenth centuries (D. J. Huntley).

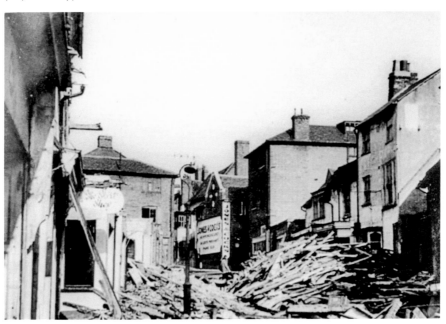

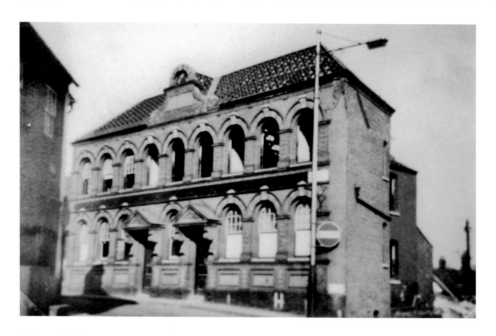

Slipper Baths

The old 'slipper' public baths, taken during demolition. The whole East Side of Bourbon Street was demolished to accommodate the new shopping emporium of Friars Square. Back in time, the 'slipper baths' were a sort of health club for the poor (John Reed). The area was levelled by the mid-sixties development. This is the site of the old 'slipper baths' in August 2010. It shows the western entrance to the redeveloped Friars Square shopping centre.

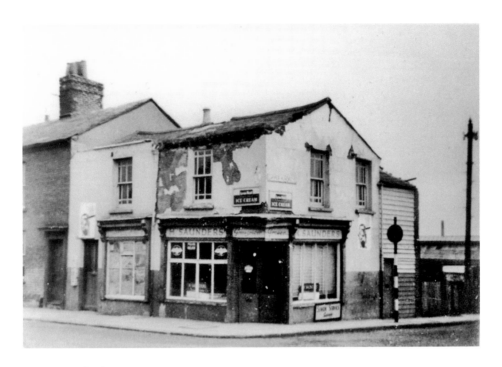

Upper Hundreds

This tatty old shop in Upper Hundreds was on its last legs when this picture was taken in the early 1960s. The site was redeveloped in the 1960s, making room for the post office sorting office.

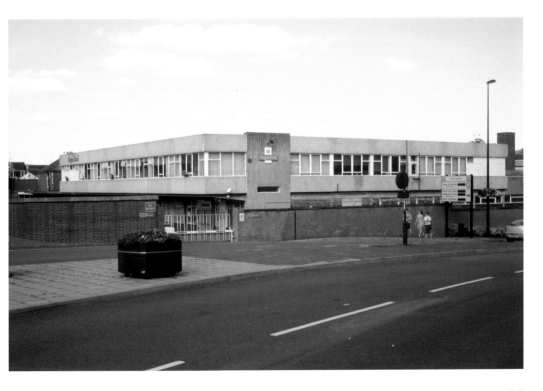

Dunsham Lane

It is hard to believe that this lane, shown here in the late 1950s, is just off Buckingham Road and almost opposite the Royal Bucks Hospital. Aylesbury was still very rural and at the heart of a farming county (John Reed). Today, Dunsham Lane is just another housing estate, swallowed up during the 1960s rapid and optimistic growth era. Sadly, the beautiful old oak was cut down in May 2011.

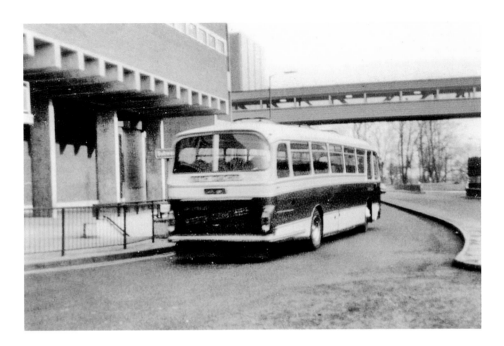

Friarage Road

This picture shows one of the Red Rover/Keith Coaches fleet leaving the new bus station and heading east in 1967. The original pedestrian bridge, linking Friar's Square shopping centre with the multi-storey car park. This wider angle shot, taken in August 2010, shows the shopping centre and multi-storey car park. A new bridge was put in place during the early 1990s renovations and refurbishment of the shopping centre and car park areas. The world of public transport has changed. The Silver Rider bus shown in the picture was operating a local service to the high density Fairford Leys Housing Estate south of the town.

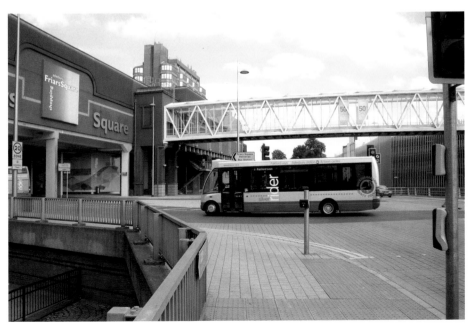

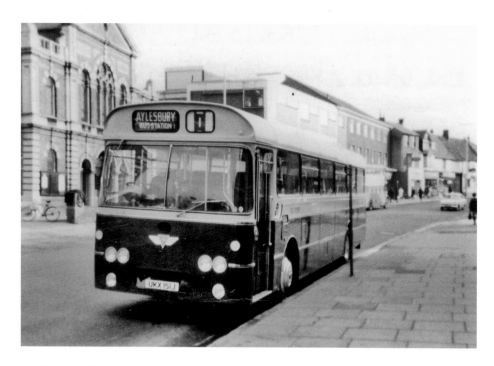

Buckingham Street

Continuing the public transport theme, this is Red Rover's new AEC Reliance, pictured outside the company's Buckingham Street offices in January 1971. Pages of Aylesbury's baker's and confectioner's shop is one of several old established Aylesbury businesses visible in the background. The building line in Buckingham Street has changed very little, but the buses and the old businesses have gone. The chapel is still there, but the congregation is not so large.

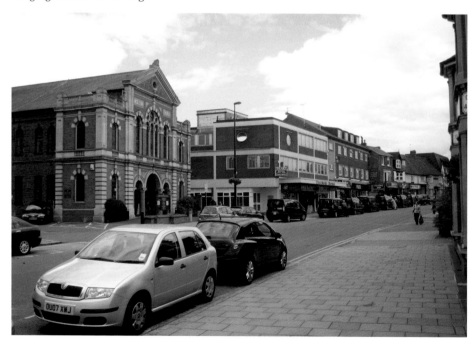

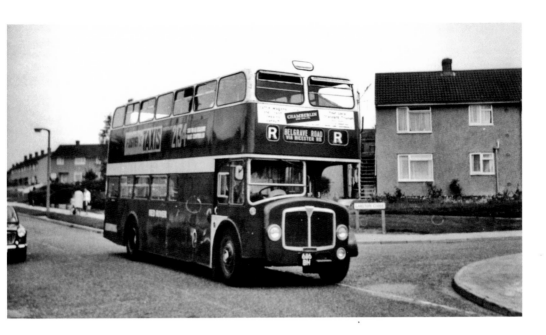

Carlton Close

Public transport still seemed to have a future in the mid-1960s. This is why the local Red Rover Omnibus Company bought three 71-seat double-decker buses. This picture shows their second AEC Bridgemaster on Saturday 4 September 1971. It is approaching the Belgrave Road terminus near Carlton Close. This estate developed rapidly in the 1960s, along with light industry – much relocating from London, like Nagretti & Zambra and Percy Fox Wine Traders Consortium (R. C. Barton). Viewing Aylesbury from the same spot today, we see some subtle changes. There are a lot of private motor vehicles in view. Public transport has been on the wane since the early 1980s.

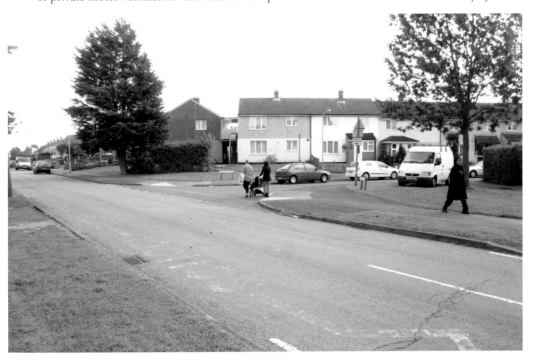

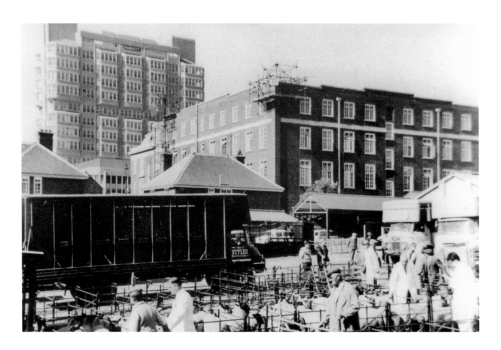

Aylesbury Livestock Market

Super-quick builder Marriot's banner stands high on the newly completed County Office building, in this 1966 view from the old cattle market. When routine maintenance was carried out on the prestige tower block in the mid-1980s, the builder was found to have skimped on the quality of concrete blocks; many were almost hollow. There was no redress from Marriot's as the Kier group had swallowed them up. The 1960s were renowned for shoddy concrete edifices (Reg Jellis). This early 1990s shot shows the cattle market being excavated for the foundations of a new multi-screen Odeon Cinema to replace the old, equally innovative 1930s Odeon in Cambridge Street. Cinema was then enjoying a rebirth after years of being usurped by television.

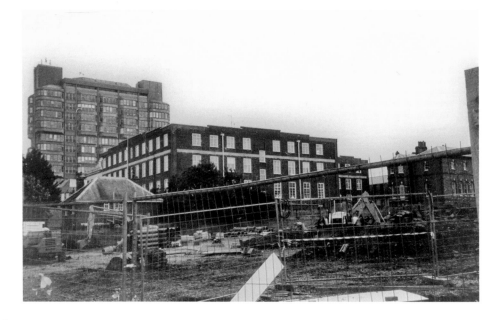

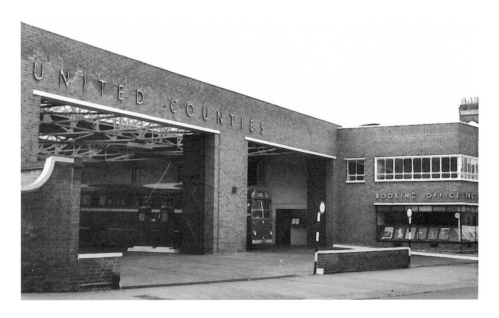

Aylesbury United Counties Bus Garage

By the 1930s, two major bus groups had consolidated routes across England: the British United Traction and Thomas Tilling Ltd Tilling took over Aylesbury Bus Company in the late 1920s. Their Eastern National subsidiary ran local services, connecting with Luton, Bedford and beyond. In 1952, these services were transferred to their United Counties subsidiary. The company continued operating from this garage until Thatcher's government sold the National Bus Company off, at knock down prices, to private companies.

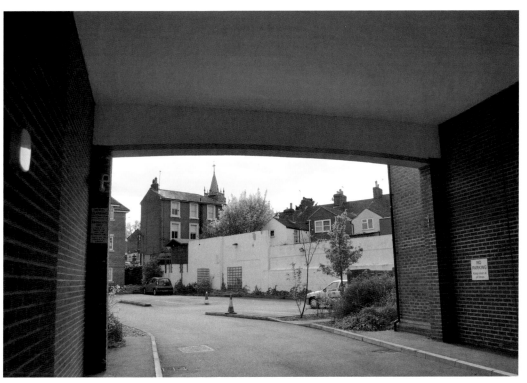

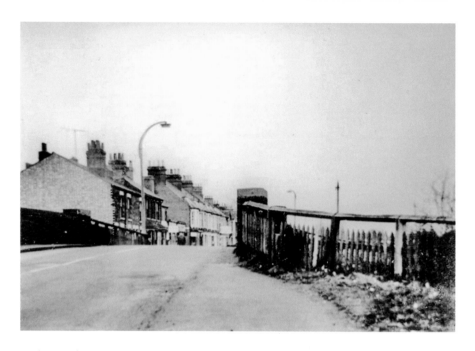

Stoke Road

This bridge over the High Wycombe branch of the Aylesbury–Marylebone rail link is seen here in the early 1960s. The road leads to Southcourt and Stoke Mandevelle Hospital (John Reed). The scene looks little changed today, though it leads of the now hectic late 1960s gyratory system, which has created an island off buildings, surrounded by an almost constant traffic flow.

Chapter Three

Dormitory Town

From the idealised car-free town centre of Aylesbury's 1960s Friars Square, the town, like the rest of the country, has progressed – if that is the right word – to the out of town world of shops, like Tesco superstore *et al*, off Bicester Road.

The town centre is not the bustling place it used to be. Buses don't bring in in droves of shoppers on Wednesday and Saturday market days any more. Two major local bus companies vanished in the mid-1980s.

New homes were built, but council houses were sold off. Property prices went through the roof and the whole town became about commuters who could afford mortgages for escalating house prices.

The social fabric of the town changed massively, as even those living in tiny terraced homes now need big salaries for the privilege and, as the economy has become more precarious families have cut spending in a town more dependent on retailing than manufacturing.

As population density and traffic flows have increased, it has been harder to paper over the cracks. Back in the halcyon days of the 'Swinging Sixties', problems were mild by comparison, but they did exist, as this 1960s local news report attests:

> Carlton Close; a cul-de-sac on the western tip of Aylesbury's new Bicester Road estate, is quiet in the day-time when the children are at school. But in the evenings and at weekends the children play in the street. And they are noisy.
>
> Frequently they are asked to go away. Sometimes they play instead in the garage area between the Close and Grafton Road. But this wakes younger children, sleeping nearby, and angry parents move them on again.
>
> The main trouble, say people living along the street, is that there are no playgrounds in the vicinity.

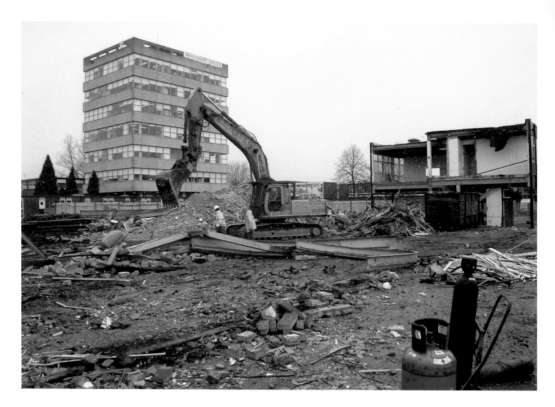

Aylesbury College Demolition

The original college of Further Education during demolition in 2005. The college was opened by Princess Alexandra in 1964. It cost £315,000. By 2005, the new building was a chance to change the image. Thatcher's reforms saw the college break away from Bucks County Council control.

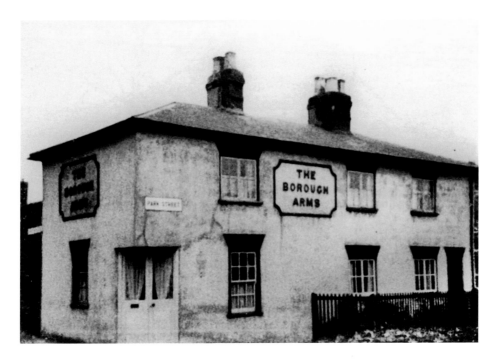

The Borough Arms

The town's architecture was not always so exotic. This image shows the original Borough Arms, near Tindal Hospital, on 19 June 1959 (John Reed). The new Borough Arms at the junction of Tindal Road and Park Street is much brighter and has a beer garden. Now called The Weavers it is a thriving public house in the difficult age that has seen the local Walton Brewery taken over by Aylesbury Brewery Company and then that company disappear in the 1970s.

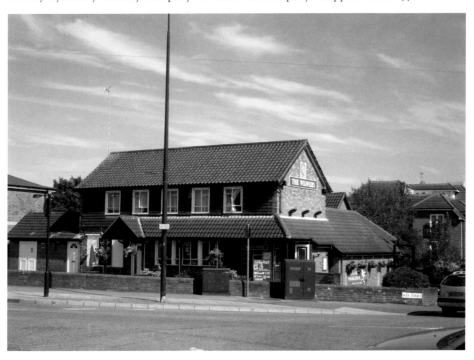

Chamberlain's Workshop, Buckingham Street
From the earliest days of motor transport, the business handled anything from building car bodies to horseboxes. It closed in the early 1980s to make way for Sainsbury's (Ron Rayner). Sainsbury's town centre supermarket, built on the Chamberlain site and seen here in July 2010.

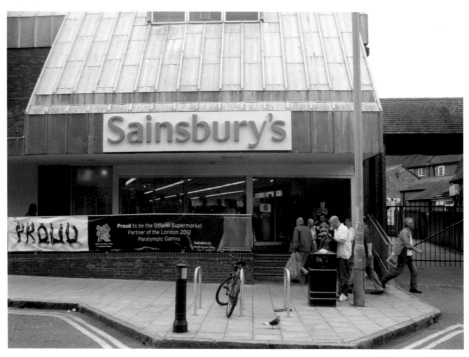

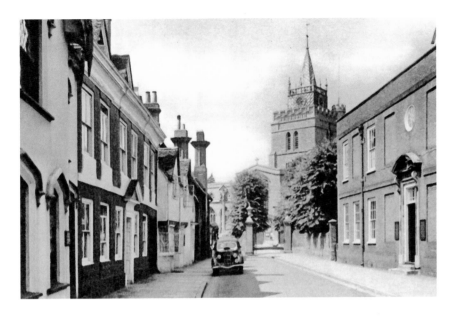

Church Street, Late 1930s

Nowadays, it is difficult to find a parking space here. Early this century, Dr Baker used the house on the right as his living quarters, surgery and drug dispensary. He followed a tradition started by the previous resident and eminent local doctor, Richard Ceely, a driving force behind the establishment of the Royal Bucks Hospital. Ceely also won admiration for fighting the cholera epidemic of 1832. Dr Baker is remembered for having the first motor car in Aylesbury (D. J. Huntley). The tranquillity of Church Street remains, but Dr Baker's old home is now a store of memories as the Bucks County Museum.

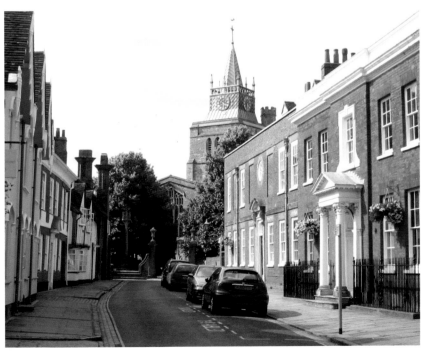

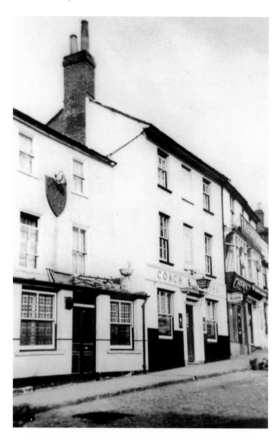

The Coach & Horses, Silver Street
This was one of three pubs left in Silver Street after the demolition of the Greyhound to widen Great Western Street. This pub would soon be turned to rubble and dust (D. J. Huntley). Gone are the banter and liveliness of the old Coach & Horses. Sixties redevelopment saw the gradient levelled and the modern age of office blocks and shopping centre redefined what Aylesbury was and is about.

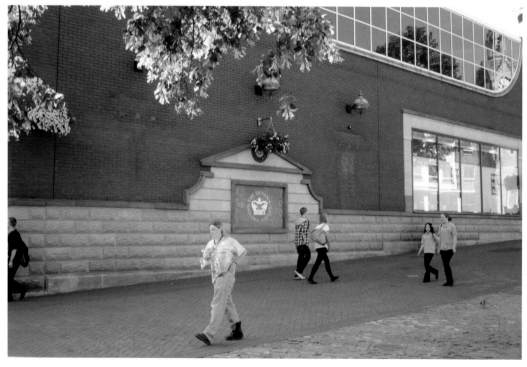

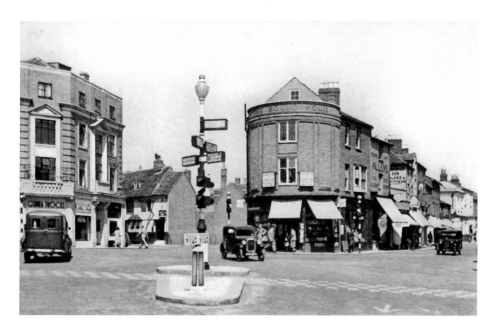

Cambridge Street/High Street Junction

The roundhouse, at the junction of Cambridge Street and High Street, has changed a lot over the years. This popular postcard scene was taken from the Market Square. The signpost informs us that what little traffic had to come through the town centre, when this photograph was taken in the late 1940s, had to pass through this bottleneck. There was no inner or outer ring road. Special Constable Ron Rayner was one of those who did point duty here at peak times. In this contemporary shot, the two major buildings and the road layout make the location easily identifiable. There is still a pub on the corner, just before Buckingham Road's junction with Cambridge Street, but it has been rebuilt.

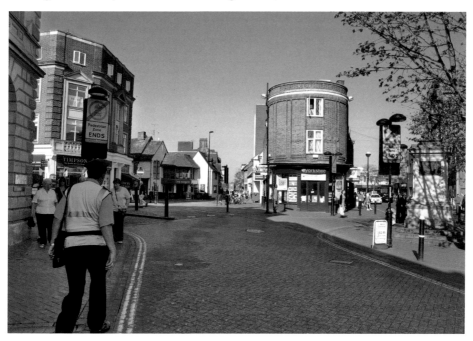

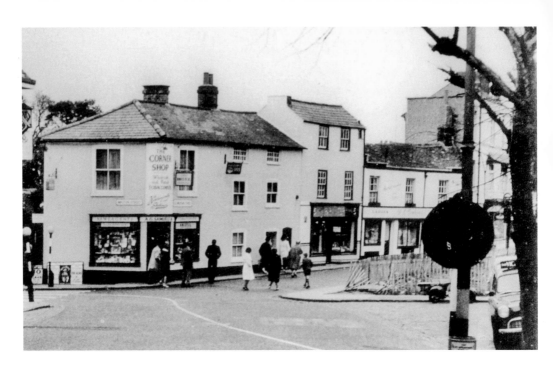

Walton Street Junction

The junction of Walton Street on the left and Silver Street on the right, with the Market Square and Great Western Street, *c.* 1959. The corner shop did much business with people passing by *en route* to the railway station. This picture looks more like Chinese New Year celebrations than a day in Aylesbury's life. It would be hard, if not impossible, to recognise the same location in this image from May Day 2010.

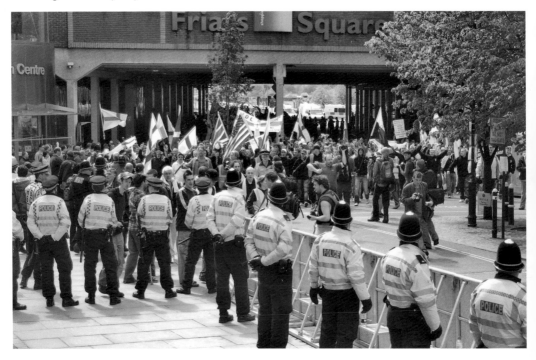

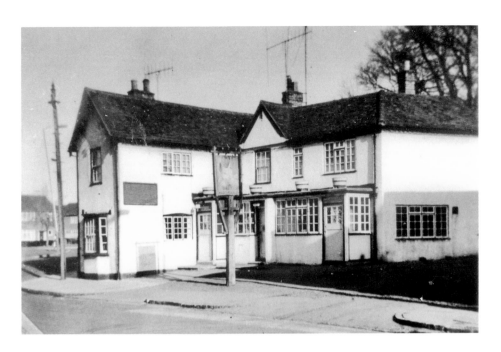

The Hen & Chickens Pub

The original pub at the bottom of White Hill on the Oxford Road. The 1960s council houses, near the junction of new Gatehouse Industrial Estate in 1963, are just in view (D. J. Huntley). Ever since the Second World War, when U.S. service men swarmed over here, there has been a sad affection with the most vulgar aspects of U.S. culture. And so we find that the new pub – rebuilt to make way for the new road scheme – was renamed Big Hand Mo's. The millennium came and this haven for Aylesbury College of FE's student boozers was demolished after a fire. Not surprisingly, the site was profitably redeveloped as high-density flats.

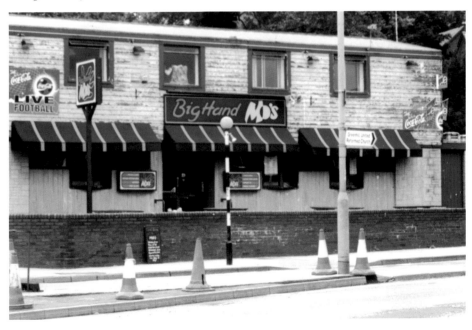

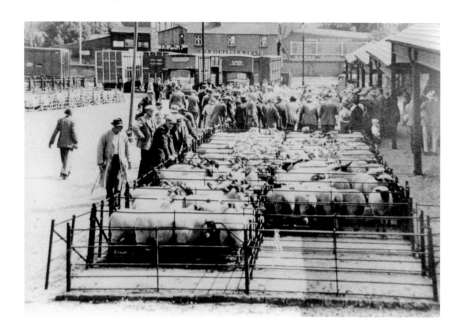

Aylesbury Livestock Market

The building industry used to be a more sedate and ponderous business. Richards' timber yard was a major timber supplier to local builders during the days when it is seen here, in the 1950s, on Exchange Street. Jewson took the yard over in the 1980s and the livestock market in the foreground is now long gone. The loss of the cattle market was a defining moment in the 1990s. Agriculture has withered. Nowadays houses are the best crops for farmers as the nation imports more and more of its food (Reg Jellis). The photographer would have to stand inside a building to capture exactly the same shot today. The tacky building in the centre is a pub called The Slug & Lettuce. The Civic Centre was still standing and awaiting final performances from stars like one-time rebel Paul Weller.

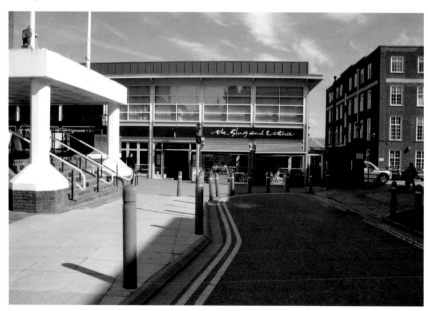

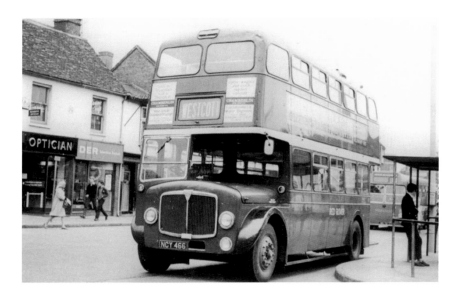

Kingsbury Square

Aylesbury was the terminus for five major bus operators in the 1960s. Red Rover was the little guy amongst them. E. M. Cain founded the company running express services to London, until taken over by London Transport in the 1930s. Red Rover had an eye for a bargain. The second-hand example pictured here was an ex-South Wales AEC Regent in Kingsbury Square, in 1968. Its destination is Westcott, and then still home to the government's rocket propulsion unit – founded to examine and develop the ideas of Nazi and U.S. Space race man Dr Werner Von Braun. In this contemporary shot, we can see the building that housed TV rental shop DER is still there but a modern structure now dominates the east side of Kingsbury.

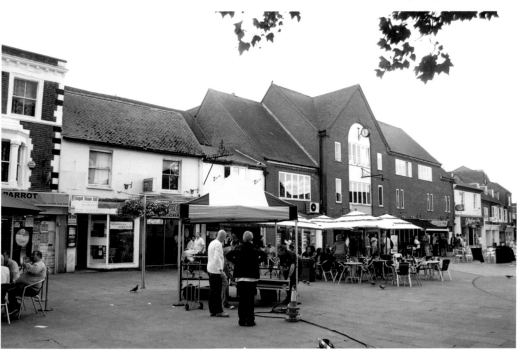

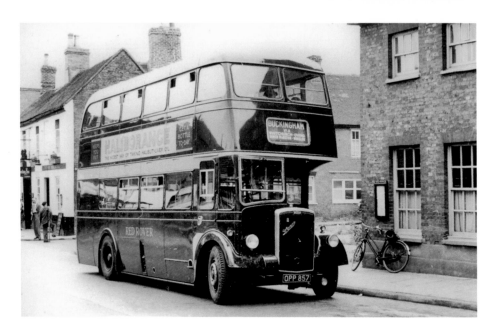

Kingsbury Square

This Dennis Lance K3 was the last new bus purchased by E. M. Cain for, his Red Rover fleet, before he sold out to Keith Garages. It is seen here, brand new, in Kingsbury Square. The Red Lion is visible in the background, by the turning to George Street (R. H. G. Simpson). The bus stop went when the new bus station opened in 1968. The Coral betting shop occupies the premises originally built for the Record Centre in the early 1950s. The author recalls winding his way through the legs of a crowd gathered to see Scottish pop hero Jackie Dennis opening the Record Centre, ushering Aylesbury into the pop age.

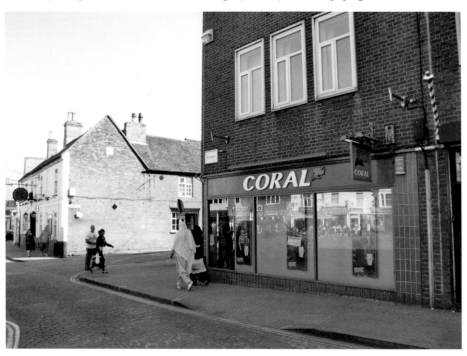

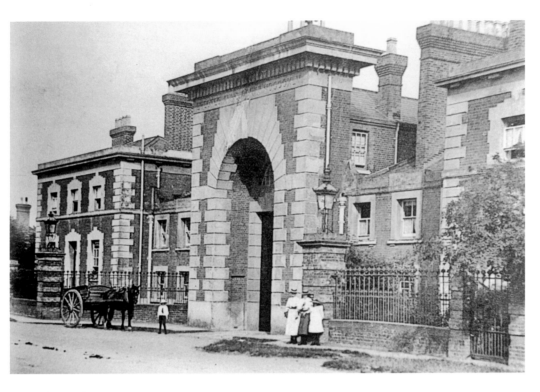

The Gaol

The new building, which opened in 1845, was more comfortable than its predecessor. Sightseers loved it. On 28 March 1845, a crowd of 10,000 flocked in from surrounding villages to watch John Tawell hang for the murder of Sarah Hart. He was the first criminal to be caught by means of the telegraph, having escaped by train. Today, the gaol is a young offenders' institution.

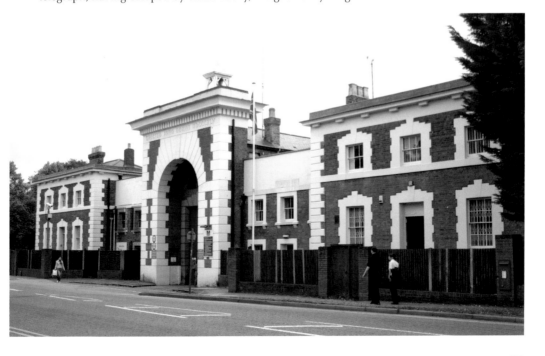

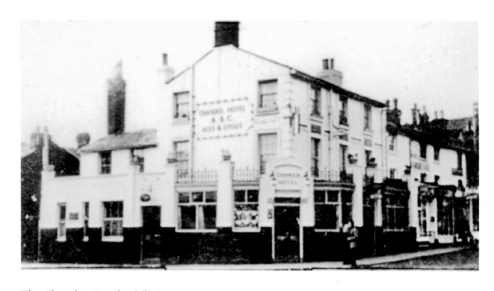

The Chandos Hotel, High Street

This hotel took its name from Lord Chandos, Duke of Buckingham and resident of Stowe. Its shoddy ornate appearance was typical of local pubs of this age (Buckinhamshire County Library). This wider view of the same location shows the AVDC offices built on the old Chandos site and the one-time insurance company offices on the opposite side of the High Street. The entrance to Railway Street is also on the site and led to the original Aylesbury railway link to London via Cheddington, which opened in 1839.

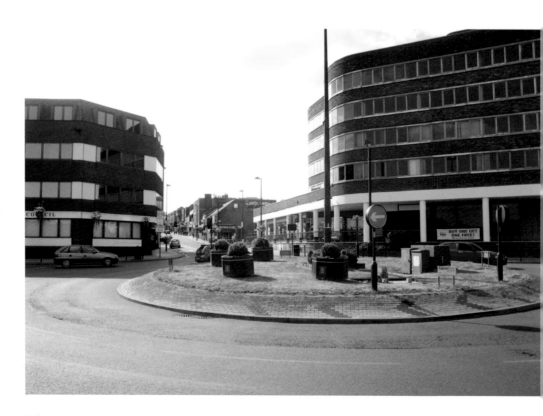

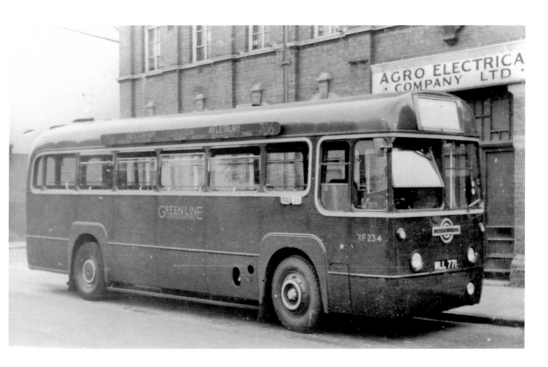

Buckingham Street

London Transport Greenline RF coach, outside Agro Electrical premises in the early 1950s. Greenline services took over from E. M. Cain's Red Rover in the early 1930s, following nationalisation of express coach services into London. Demolition in this area in the early 1960s afforded a TV company the opportunity to simulate and film a plane crash for the popular *Emergency Ward 10* hospital series (R. H. G. Simpson). The same location today has been overwhelmed by sixties and eighties retail and office architecture.

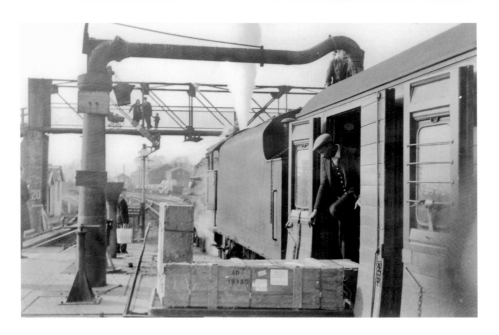

Aylesbury Town Station

This was a busy thoroughfare when this mid-1950s picture was taken. Trains roared and thundered north on the Great Central Railway tracks. Here we see a steam loco taking water while the guard dealt with freight. Meanwhile, a young couple with child and infant in pram, pause *en route* to their council home, via the old over bridge. They and their offspring are clearly enjoying the drama of the busy station scene. The West Indian guard shows the country's post-war reliance on immigrant workers to man its transport system. The train is heading for the Midlands. Seen here in April 2011, one of the newer sprinter trains is ready to roll, the old over bridge has been replaced by a modern and much larger structure as part of the town's major facelift.

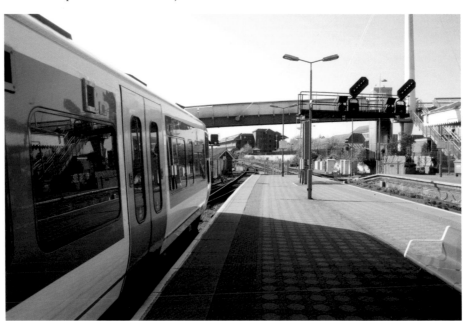

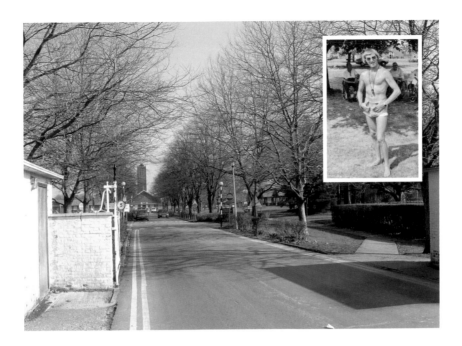

Stoke Mandeville Hospital, *c.* 1967

Top of the Pops and BBC Radio One disc jockey Jimmy Saville was a frequent visitor and volunteer worker at Stoke Mandeville hospital from the late 1960s and 1980s. This inset shows Jimmy posing with patients in the background (Maurice Tasker). Stoke Mandeville hospital played a key role pioneering plastic surgery and helping paraplegics, developing a world-class reputation during the Second World War. The hospital has also been host to the World Paraplegic Games. However, the buildings have been replaced by large new ones, south of the old site.

Chapter Four

True Blue

The nation was virtually bankrupt after the Second World War. Housing was in short supply and many had to live in prefabricated homes on temporary sites. Southcourt council housing estate was built in 1951. The town had been designated an expanded town, to take London overspill. Many would flock here under the terms of the 'Greater London' Scheme. In homage to the inspirational wartime leader Sir Winston Churchill, one of the estates main roads was called Churchill Avenue – not surprising, given Aylesbury and the county's true blue pedigree.

This writer recalls the demands of delivering the Christmas post on that estate, in the late 1960s. Every little house had a front gate and garden path. With Christmas cards and electricity bills in his sack, he had to go up and down paths for hours on end.

By the end of the decade, work had started on Aylesbury's large private housing development at 300-acre Bedgrove Farm. Luton firm H. C. Janes won the contract. The firm's chairman, Leslie Snell, used a silver trowel to lay the first brick. Mr Snell used the same trowel to lay the last brick on 1 July.

Half way through the estate's construction, the *Bucks Herald* wrote:

Think of Bedgrove and you think of a half-finished estate right on the edge of the Borough of Aylesbury. It's already a large estate, but with no shops. Some of the roads have already been adopted by the Borough Council, while others, still private streets belonging to H. C. Janes Ltd., the builders, are muddy and half made up.

Bedgrove, for a lot of the residents there it means the invasion of their privacy by the erection of what they fear may be 11 storey blocks of flats.

Many of the streets are dark at night, not yet having been connected to the street lighting supply. All these things are inconveniences that must go with a young developing estate. Most of the people expect them and hope that soon things will get better.

One of the longest roads on Bedgrove is Ingram Avenue. Curving from Bedgrove itself around to Welbeck Avenue, it again is a half-finished road. Many houses along it are still in the course of construction.

Residents of Ingram Avenue are a mixed bunch. By no means all of them come from the London. Some are from the north, others are from the Midlands.

The newspaper went on to report how happy the Kimbers were to come up from living in one North London room, to a house on Oakfield estate. Mrs Kimber said she could not understand why so many of her neighbours went back to London.

H. C. Janes went on to build more new homes next to Stoke Mandeville School on Southcourt.

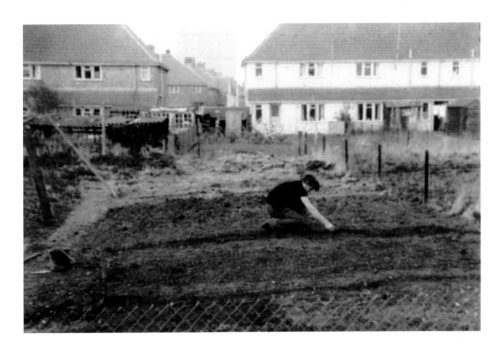

Southcourt Housing Estate, 1965

This mid-1960s image of Southcourt shows the new County Offices building. It also shows how generous the council was with land for gardens. Self-sufficiency was not impossible for the keen vegetable grower. Baker's Toys & Cycle shop was this writer's favourite place back in the 1950s and 1960s. This image shows its final days, early in the new millennium. My parents had little money, but just window-shopping – looking at model trains cars and trucks – made me very happy.

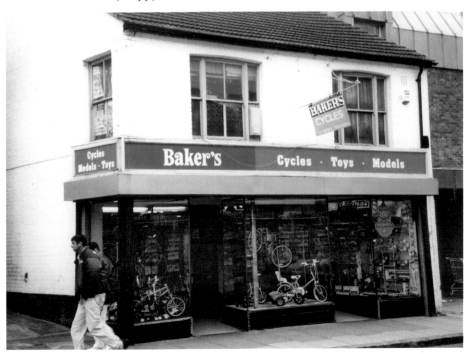

Baker's Toys & Cycle Shop

Out-of-town shopping centres and big stores like Toys R Us finished off little toy wonderlands like Baker's. Today's businesses come and go, like the one named here on the old Bakers' premises. Aylesbury has more than its share of charity shops and the two shopping centres are mainly about women's clothes. Here we see a poster advertising the U.S. series *Nip N' Tuck*. The Royal Bucks Hospital is just visible to the left, but there was no 'nip and tuck' surgery for modern women available there on the NHS.

Whitehill, 2010

A block of tiny, expensive flats in this summer 2010 shot has replaced, almost inevitably, the old office block. Redevelopment of the original sixties Friars Square is underway here in 1990. Thirty years on, the futuristic concrete was just passé in the town's struggle to compete with the retail Mecca of Milton Keynes.

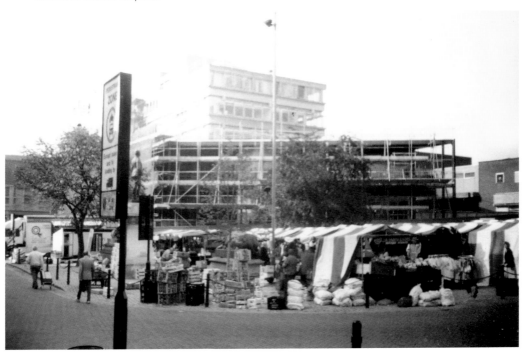

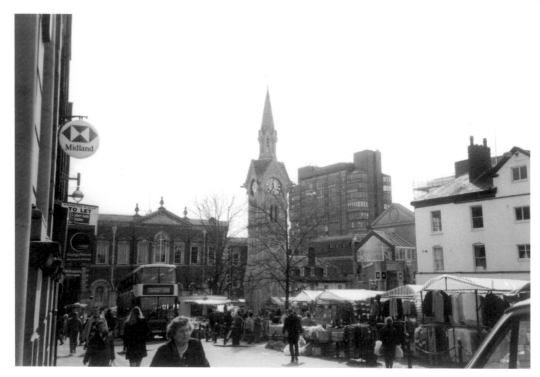

New Friars Square

By 1995, the new Friars Square had blended in and was going strong in the world of selling fashions and electrical goods. The open-air market had long ago gone back to the square and the vacated space is now a coffee and eating area in a naturally lit and well-paved pedestrian space. Queen Elizabeth II visits Aylesbury (left) during her Golden Jubilee Celebrations, in 2003, in Aylesbury Market Square. Elizabeth came to the throne in 1952, during the last days of the Empire, when Britain was still entrenched in pre-war values.

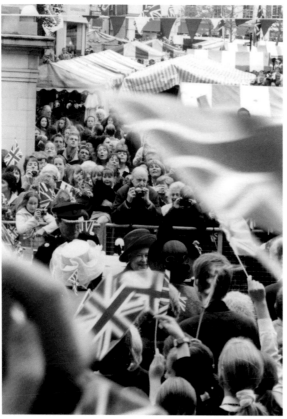

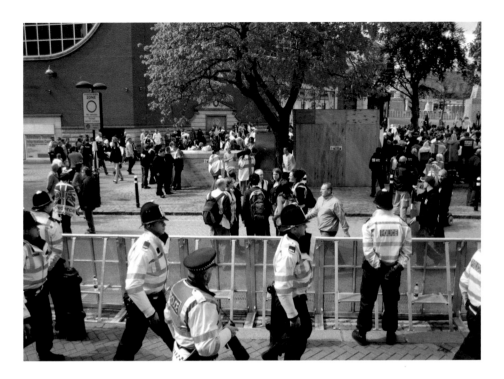

English Defence League, Market Square

Looking from the same County Court steps on May Day 2010, it is hardly a recognisable scene. The British flags are being waved, but the mood is clear and terrifyingly different. This is the day the English Defence League (EDL) came to town. An army of police officers arrived to head off any signs of riots. Looking at this little pond in Walton, it is hard to imagine that the EDL marched past here *en route* to the Market Square a hundred years later. Walton was a village then, but would soon be absorbed in Aylesbury town.

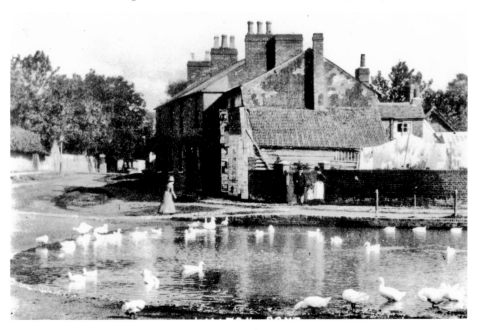

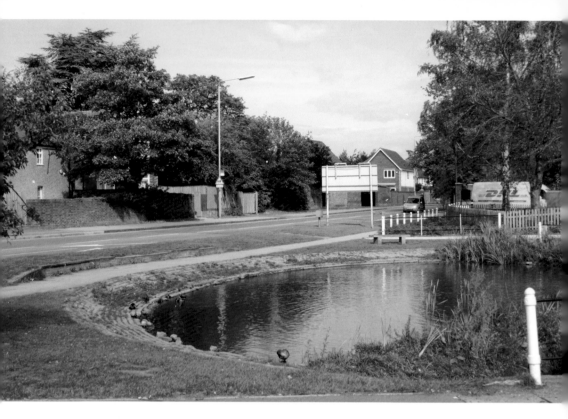

Walton Pond, 2010
The location is still recognisable as the same place today, but we see the signs that new housing has filled the gaps between Aylesbury and Walton. The town's fortress of a police station is just out of view on the right. Buckingham Park housing estate under construction below. New Labour's expansion plans forced AVDC and Bucks County Council to accommodate thousands of new homes.

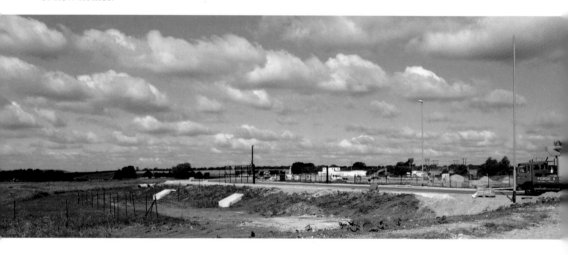

Buckingham Park Housing Estate
Buckingham Park is seen here, completed, in the summer of 2010 (Kieran Cook). Below, the 1950s Territorial Army Drill Hall in Oxford Road in 2001. The Territorials have an illustrious history, but looked like being culled after the Berlin Wall came down.

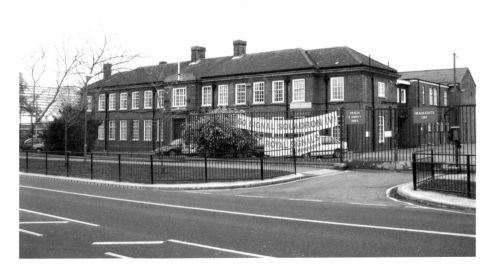

Territorial Army Drill Hall, 2010

A modern army needed a new drill hall. This is the new building for the 'terriers', pictured in the summer of 2010. This site is in front of the 1960s Gatehouse Industrial Estate. Much of that site has now been demolished. The author recalls a period working at the Percy Fox Wine Trader's Consortium. It was a madhouse, but great fun. We used to swig the wine bottles before they were full and then top them up. A view from the bridge over the rail tracks by the town station. The Schwarzkopf building is being demolished and the county office building looks lovely against this small commuter town skyline.

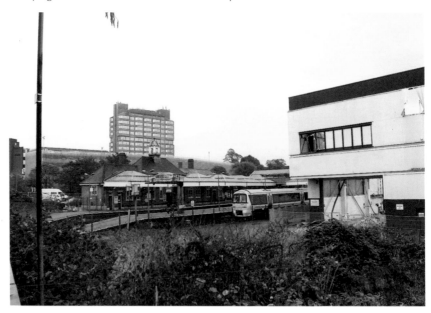

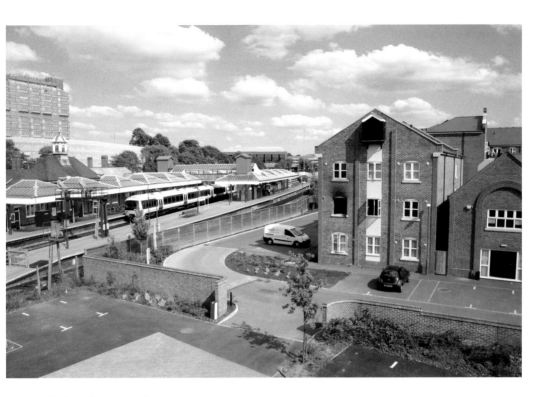

Aylesbury Town Station

The year is 2010, summertime, and new high density and high cost flats have been established on the old Schwarzkopf site. We see evidence of fire in one of the windows, a reminder of the hazards of communal life. Below, this is 2003, on the old concrete bridge over the town rail station tracks.

Concrete Bridge

Everything looks wonderful in this summer 2010 image, taken from the same spot as in the previous one. Below, a southeast view, from county offices, in 2003, shows the old Nestlé building and *Bucks Herald* Offices in Exchange Street. Exchange Street gets its name from being the road where the original corn exchange was located.

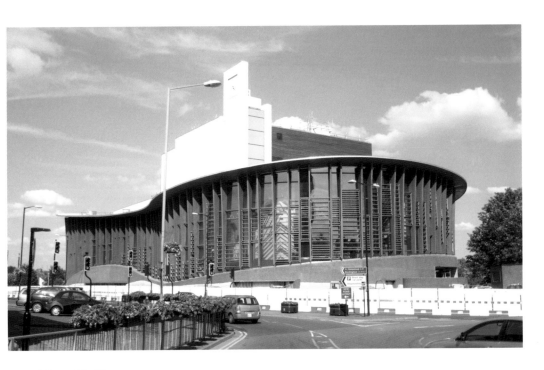

Waterside Theatre

The controversial new Waterside Theatre is seen here just after completion in 2010. The economic importance of the original Grand Union Canal was short-lived. However, in the twenty-first century being by water has huge economic significance in itself. The theatre was built partly on the old *Bucks Herald* office site. The charabancs are all lined up, ready to take the locals on excursions around the locality or even to the seaside. The business would go on to take over E. M. Cain's Red Rover Bus Company and become a major local bus company as well as a very successful car dealership (Stuart Mills).

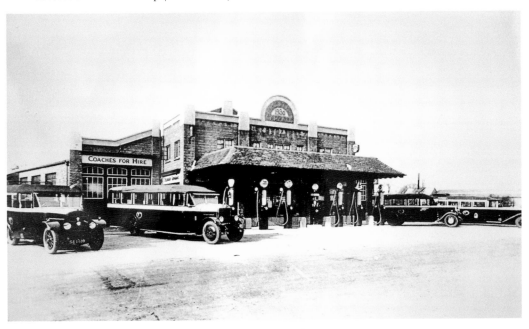

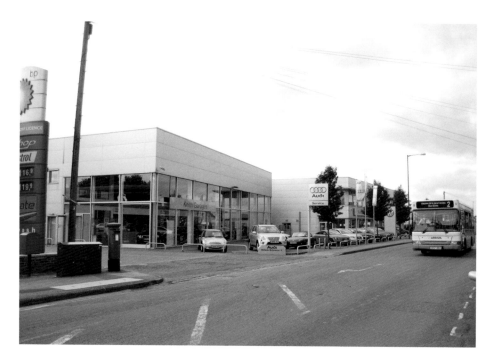

Keith Garages, June 2010

The Red Rover Bus Company was sold off to Luton & District in 1985. Keith Garages now focuses on car dealing and servicing. Luton & District were taken over by Arriva, part of the Cowie Group. The Odeon cinema was opened in the 1930s heyday when Hollywood made pictures to take minds off of unemployment and hardship. When the Second World War came, deferential locals did their bit for their betters, and the cinema entertained locals and troops from camps like Hartwell House with propaganda films.

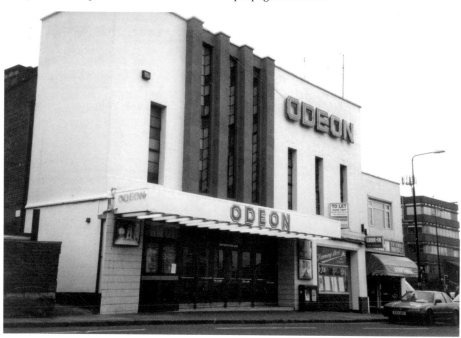

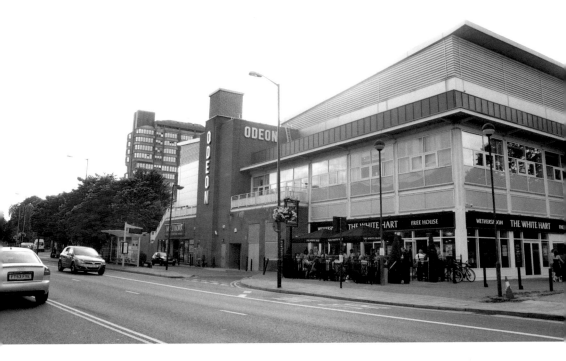

Odeon Cinema, Exchange Street
The new Odeon Cinema opened on the old Cattle Market site on Exchange Street. The multi-screen complex still offers escapism in an industry dominated by the U.S.

Chapter Five

Big Issues

At the time of writing, there is a great deal of fuss in the Aylesbury Vale's surrounding green pastures. It is not about rural homelessness, rising drug taking, unemployment or crime. It is all about the great and good living in and around Wingrave panicking about planning permission being given for a rock concert this summer, at Burcot Farm. The area's terribly posh County Councillor told the TV news: 'It is very worrying. These people will undoubtedly escape from the festival site to explore – and they won't be sober.' This attitude is time-honoured in and around the county town.

The County includes some of the wealthiest people in Britain. Back in the 1940s, the local Communist party candidate was beaten up in the Market Square. Rebel bands like the Rolling Stones performed at the Granada Cinema, but they were not really about change.

Superficially, the town went hip, and it swung with the sixties. Dave Stopps started the famous Friars Club and became manager of Howard Jones. But the closest to any form of pop music dissent was former Grange schoolboy, John Otway. His dad was a shepherd in the Lake District, finding new pastures in Aylesbury Vale.

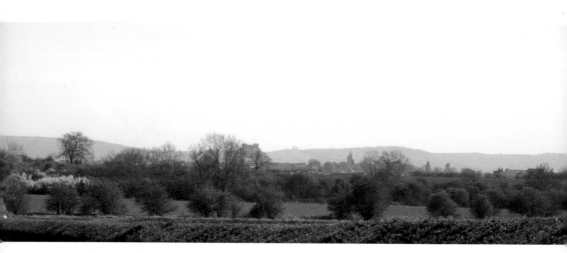

Looking south towards the green pastures of Aylesbury Vale in 2011. The 1960s County Office block and historic St Mary's church make prominent landmarks against the backdrop of the Chilterns. Agriculture has become far less significant to the local economy since the end of the Second World War. There is no work for shepherds now.

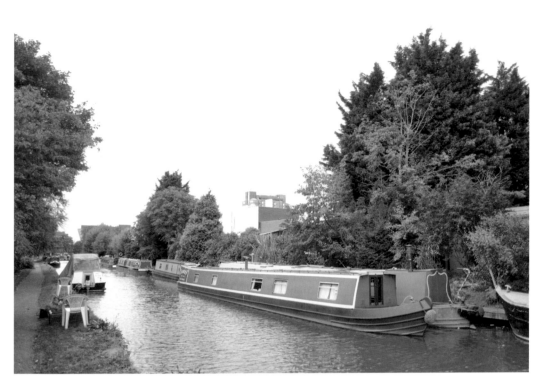

Grand Union Canal

A tranquil scene by the towpath of the Aylesbury branch of the Grand Union Canal. The canal opened in 1814, but the railway usurped its importance. These days it offers a trendy lifestyle alternative, as we can see here in the summer of 2010. Below, the Friarage Road underpass, barely a mile from the previous location.

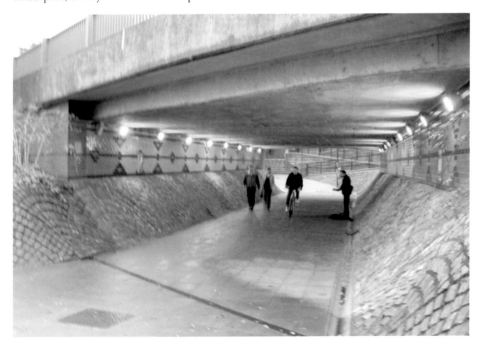

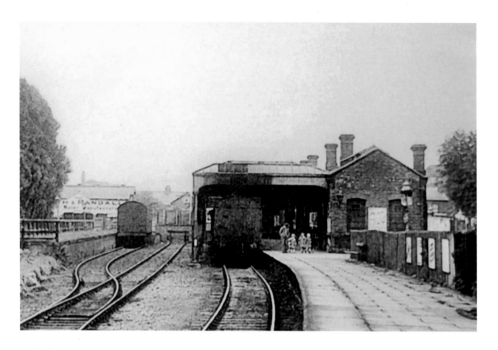

Aylesbury High Street Railway Station

North & Randall's mineral water premises are visible on the left. Both this line and the Euston main line, to which it connected at Cheddington, opened in 1839. The mail coaches were taken to Cheddington for examination after the Great Train Robbery in 1963. The train robbers were tried at Aylesbury Crown Court. The train called the *Cheddington Flyer* made its last seven-mile journey to the Euston main line on 31 January 1953. British Railways LMS region axed the line through lack of profit. The station lay derelict until redevelopment in the early 1960s. Here we see what is the rather run-down office block built on the site and occupied by a major insurance company for many years.

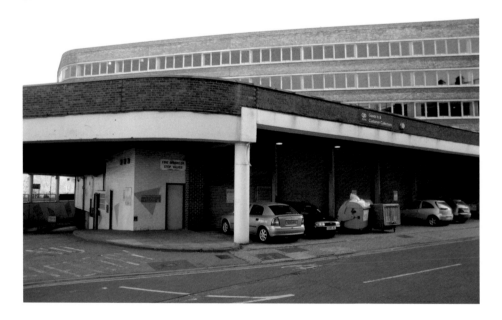

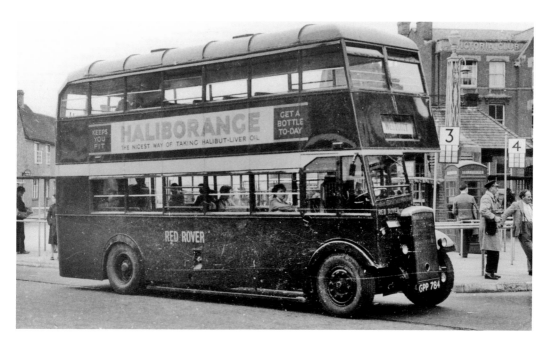

Kingsbury Square

The bus had more flexibility than trains. This 1947 view of Kingsbury Square shows one of Red Rover's Daimler double-decker buses. It was a stalwart during wartime, taking munitions workers to the munitions factory in Whitchurch (R. H. G. Simpson). These days, Kingsbury is all about leisure and evoking the Mediterranean café society.

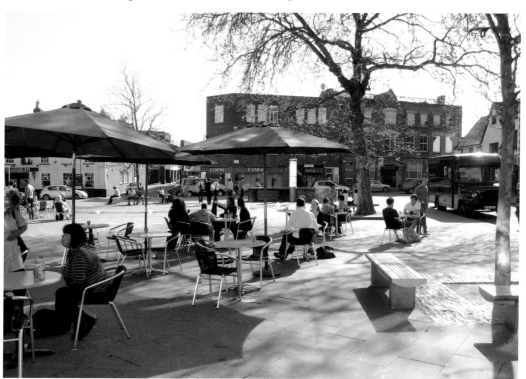

Exchange Street, 1973

A carnival scene in Exchange Street, July 1973. The approaching lorry belonged to the Gatehouse based Doughnut Corporation of America (DCA), one of the first companies established on the new 1960s Gatehouse Industrial Estate. The demolition people have been busy on this site since 1973. The canal and the new theatre are close by.

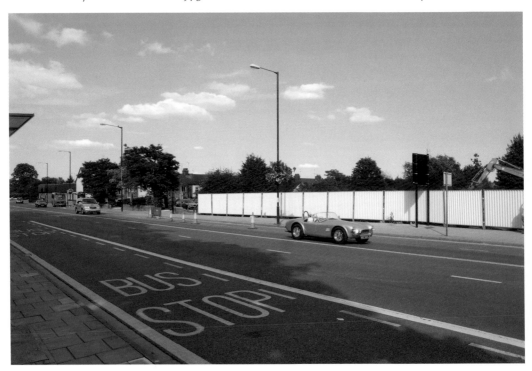

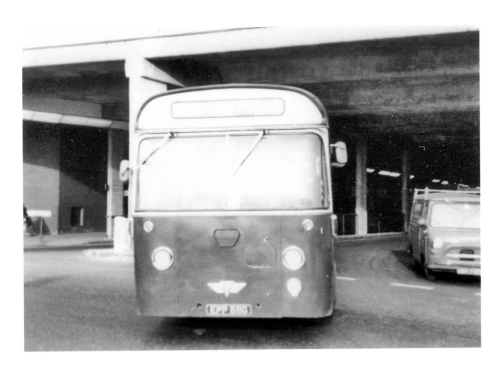

Friars Square, 1968

Red Rover's first AEC Swift exits Friars Square bus station in 1968. The concrete was new and the town was confident about its future. The basics of the original structure are still there in this shot of a bus exiting Great Western Street. But the facelift is evident in the new brickwork and the centre's name proclaimed in large letters. The new bus company is Arriva.

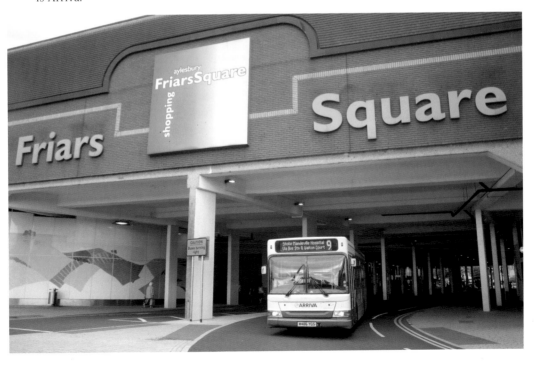

Grange School

In 1955, the pupils and staff of Queen's Park School moved to Grange School, which was then a very modern complex. The Queen, seen here, paid a visit shortly after it opened. There had been much competition to occupy the premises, not least from the grammar school. The school soon earned a reputation for excellence but was virtually in special measures after the flight of head teacher Alan Silver in the early twenty-first century. Below we see Grange School pupils waiting to see the royal visit of Princess Diana, February 1983. Her helicopter landed on the school playing field. She was taken by limousine to open Hale Leys shopping centre.

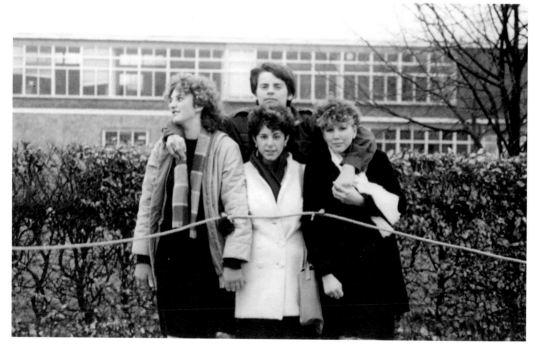

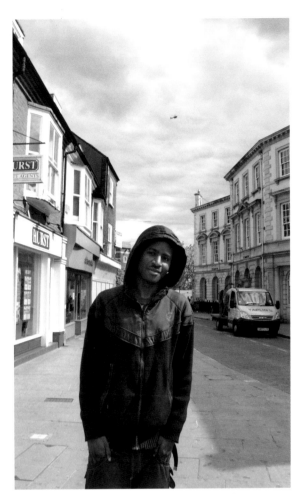

Monmouth Close, Off Bicester Road
This sixties development paid homage to the assassinated U.S. President John F. Kennedy by naming their local pub after him. Here we see 'Blac Money' pictured in Kingsbury on May Day 2010. He said that he had no worries about the EDL coming to town as he was not Muslim.

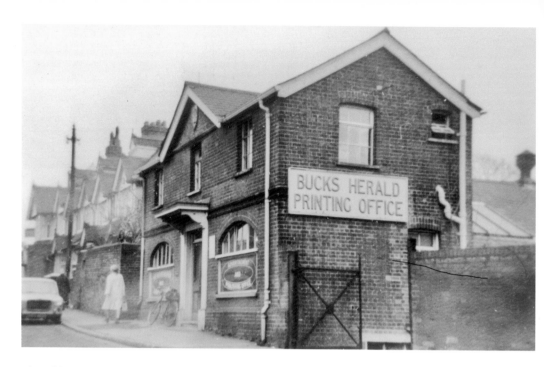

The Old *Bucks Herald* Printing Works

They were close to the town railway station, which was good for deliveries of raw material. They were also at the end of Great Western Street and we can see the ornate Great Western Hotel next door (D. J. Huntley). No sign of the way it used to be here in this 2011 shot. The print works went to make way for the entrance to Aylesbury's first multi-storey car park.

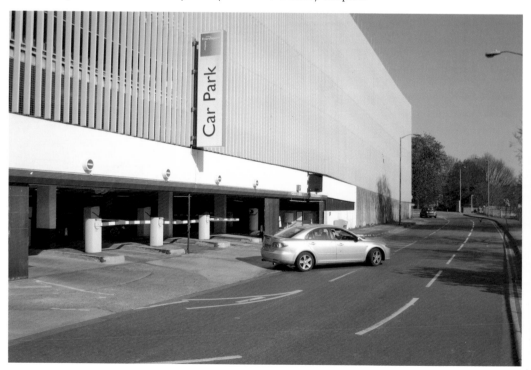

Canalside, 1980

A 1960s view of the new Bucks County Council office block. The Nestlé & Hazell's print works factory was still going strong, seen here in the foreground along with a glimpse of the old canal. It was difficult to get the same shot today, but we see here how the canal has been turned to leisure and seen much trendy new waterside residential development. But Nestlé & Hazell's factory are long gone, like so much other industry.

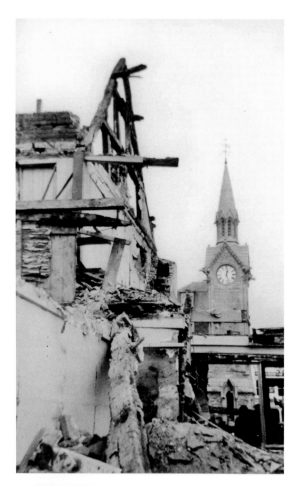

Silver Street, 1960s
A view from what is left of Silver Street during 1960s demolition. The site would be levelled and covered in concrete (D. J. Huntley). Below, from the same spot today, we are looking through the Friars Square main entrance. Maybe it's surprising, but the old clock tower is still standing.

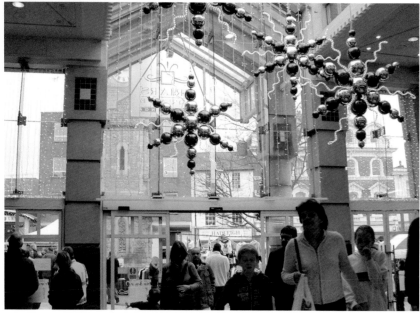

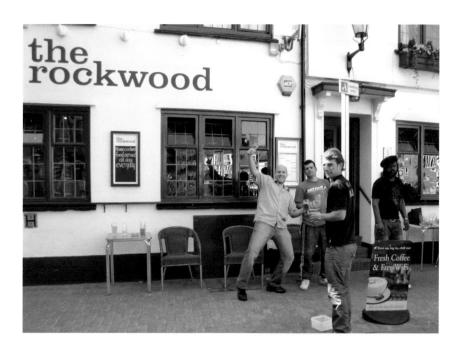

The Rockwood Pub, Kinsbury Square

Salvatore Greco studies the photographer. He takes a moment to realise that the guy taught him at his old school, The Grange. With his mates, we reminisce outside the Rockwood in Kingsbury Square. 'Has Aylesbury changed for the better?' I asked. 'No' came the collective reply, with the explanation, 'It is not a community anymore. Timothy Randall Martin founded the Wetherspoon chain in 1979. He named his business after a teacher back in New Zealand who could not control his class. He had a clear marketing concept when he opened his first pub in North London. Here in Aylesbury's Exchange Street, Wetherspoon have revived the name of the old White Hart which used to be a few yards up the street near the junction with the High Street.

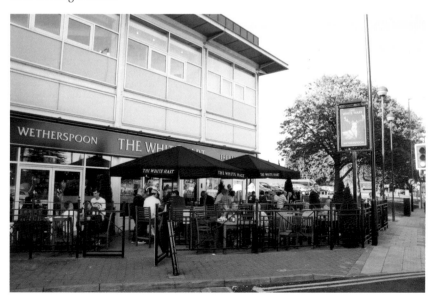

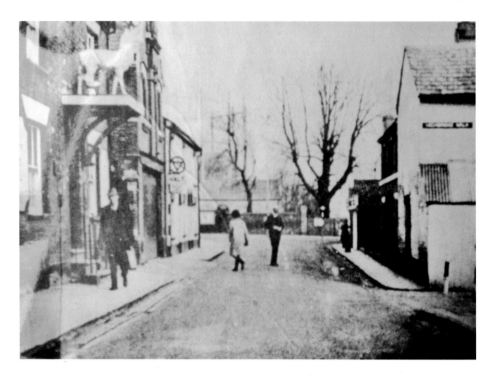

Old White Hart, 1960

The original White Hart at the bottom of the High Street in 1960. The start of Highbridge Walk is in view on the right. In this recent image, the White Hart has been replaced by offices. The little junction is now a roundabout and half the street has been demolished to make way for a dual carriageway.

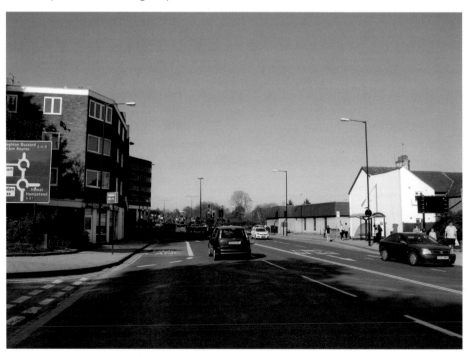

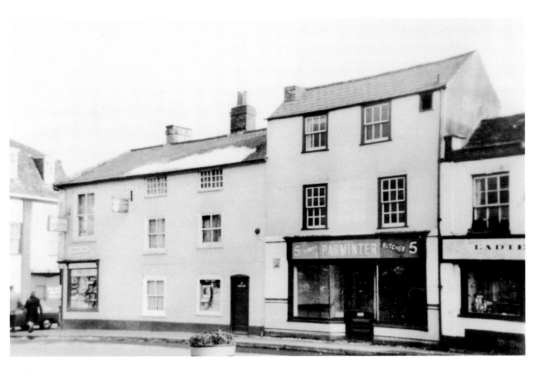

Great Western Street, 1959
This little row of Great Western Street shops, near the junction with Walton Street, in 1960, encapsulates what the sleepy little town was all about. This is what came next: a dark dingy bus station with little ventilation.

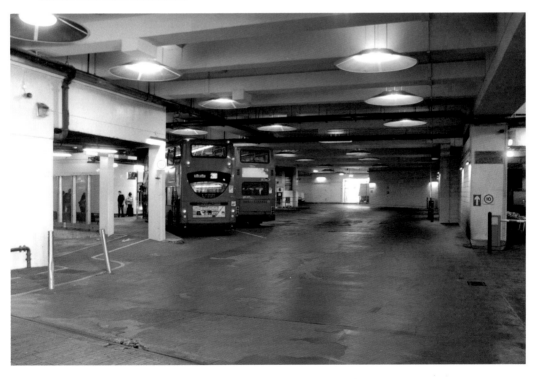

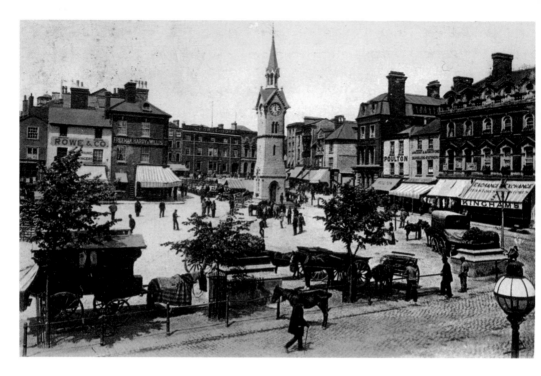

Market Square

This photograph was taken at the end of the nineteenth century. Below, the war is over and these ladies have done their bit. How proudly they parade past the county court steps taking the salute.

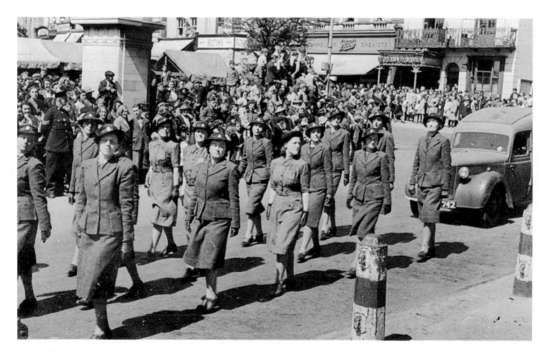

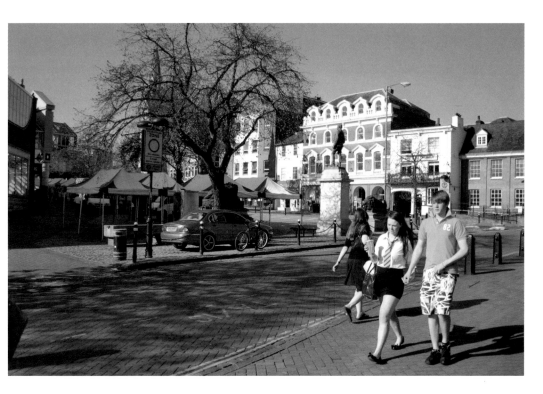

Market Square

The landscape is easily recognisable today, though the Market Theatre, like all the old names, has vanished. Aylesbury has changed in all key respects, though we see here that romance still has a chance. Aylesbury's Civic Centre was a big step up from the Market Theatre. Here we see it in 2010, when singer-songwriter Paul Weller was among the last to play here.

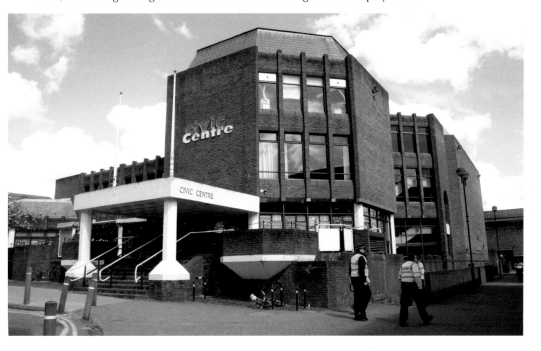

Reg Maxwell Centre

Aylesbury, like the rest of the country, is about retailing, hence the poster on the hoarding. Craftsman Ron Rayner is shown below holding one of the intricate scale model carriages he had made in his workshop, in 1995. He represented the very best of old Aylesbury.

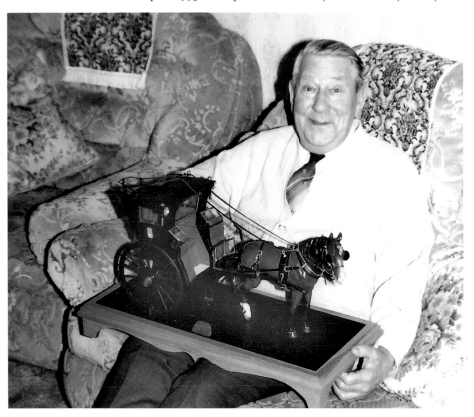

Aylesbury Town FC Ground
Land is so expensive that Aylesbury Town FC's landlords see more potential in building houses here than developing the local club. The club now plays home games in Leighton Buzzard. When E. M. Cain came from London to start his bus company, Aylesbury was a simple place. Here we see Red Rover Bus, ex-London Transport, taking shoppers to the town's first major out of centre major retailer in 1983. The shop is Tesco in Raban's Lane.

Tesco's Even More Super Store in 2011

The same location today shows hints at the major development of the Tesco site that brings in shoppers from surrounding villages. Tesco has offered price advantages that have reduced the number of small shops and heavily influenced farming. Old Odeon cinema wall, Cambridge Street, advertises the charms of the street's alternative little business in the summer of 2011. Weatherheads bookshop, off Kingsbury Square, was a favourite place for me during my late teens. Bare wooden floors blending with the sight and smell of so many paperbacks, a haven for those aspiring to knowledge.

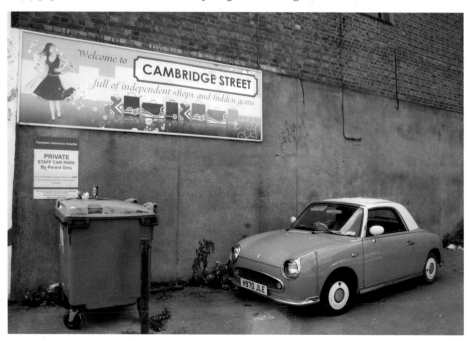

Hazell's Club, 1999

Hazell's Social Club shortly after it was burnt out in early summer 1999. Hazell's was one of the town's mainstay employers, taken over by Robert Maxwell's conglomerate. The firm died along with his empire. The old social club was a haven for Elvis Presley impersonators and other eccentric performers. Below is the same view today.

Brittania Street
This was once the High Street home of photographer S. G. Payne. He lived here from 1870 to 1912 (John R Milburn). The terraced houses were converted into shops at ground level. Of the six houses in this terrace only 6 New Road – now 53 High Street – remains. The same site, at the junction of Brittania Street and High Street is shown below, left.

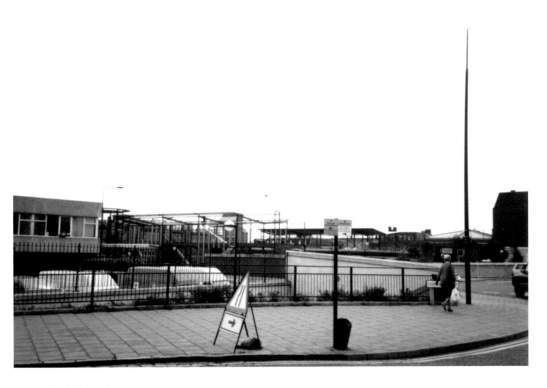

Cambridge Street, 1999

Looking from Cambridge Street toward the junction with New Street, Park Street and the bottom of the High Street, in August 1999. From the same spot today we can still see the corner of the town's post office sorting room. The major change is the giant Wilkinson's cut-price store that has risen up at the bottom of High Street.

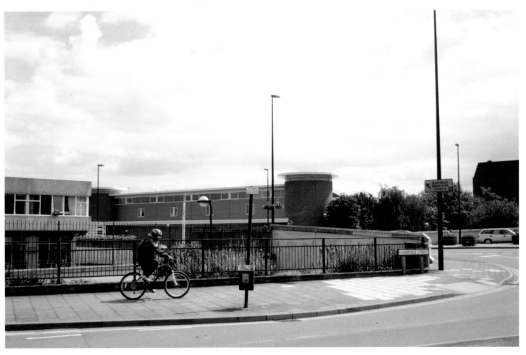

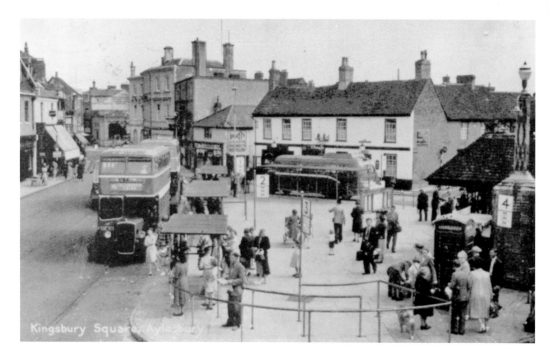

Kingsbury Square

As I conclude my journey through time in Aylesbury, it seems apposite to look back to Kingsbury Sqaure when all seemed peaceful and quiet. Back then, Halton RAF personnel were a common sight popping in and out of town by bus. All sorts mingled, chattering and shouting, to be heard over the throb of so many rumbling diesel-powered buses. Britain still had an empire and national service (Colin Seabright). Below, Kingsbury Square viewed from the same location today.

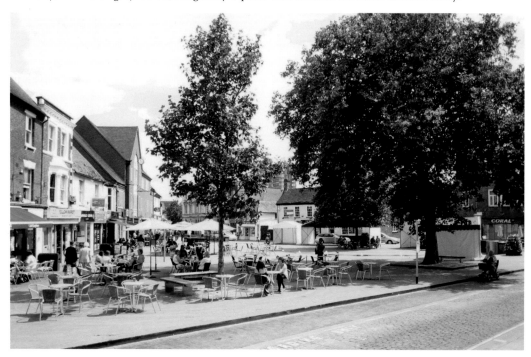

McDonald's, High Street

McDonald's is a popular fast food outlet. This picture below shows two people on the steps of the old Granada cinema in 2011. The cinema became a bingo hall years ago.

Last Word

Aylesbury has come a long way, but the mindset of its leadership is little changed. Multi-culture has made a difference, but the EDL protest in May Day 2010 suggested tensions. Officialdom is bland in its response, and highly critical of protestors. Council taxes and other costs continue to rise. These are big issues that the local media and politicians do not want to confront. This is where Aylesbury is. It has come through time with more than changes to its buildings. During preparation for this book, Mrs Baughan came racing up to me. She demanded to know why I was taking photographs in the old Market Square. 'Do you work for the council? Why are you taking pictures? Are the council planning to demolish the Market Square?'

She demanded to know all of this, speaking in a lilting Southern Irish accent. She went on: 'I hate the council. They have ruined this town. I came here when I was a child, with my family. I went to the Grange School. Lovely little school it was. This was a friendly place. Everyone knew everyone else. Now nobody knows anyone, no one talks to you in town. It is ruined. Why?' I thought of money, but said nothing.

There will be many that will not like my thoughts and conclusions about Aylesbury's past, present and future. But I have known the town on many levels over many years. I have worked in its factories, on building sites, as a postman, a local newspaper reporter, college lecturer and as a teacher at one of the town's largest schools.

As someone with a keen sense of the past, I feel it is time to look more questioningly at the town's past, present and future. There will be many who disagree, but my aim is to make readers think and ask questions about the future of their town.

Acknowledgements

The author wishes to thank all those who have helped him with stories and pictures over the last fifteen years. All pictures copyright Charles Close, unless otherwise stated.